IMAGES
of Rail

NORFOLK AND
WESTERN RAILWAY
STATIONS AND DEPOTS

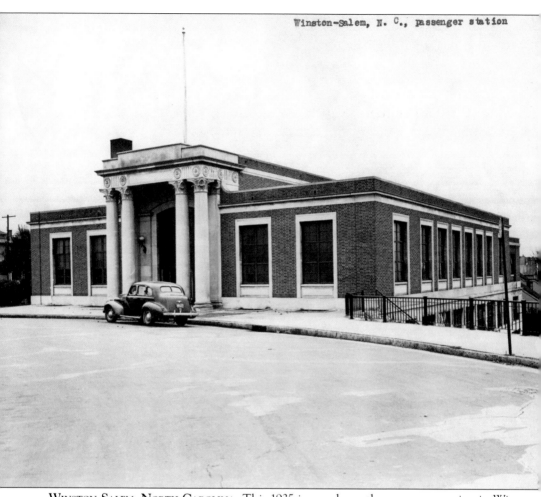

Winston-Salem, North Carolina. This 1935 image shows the passenger station in Winston-Salem. Winston-Salem was a terminus of the early Roanoke and Southern Railway, which ran from Roanoke to this city. The Norfolk and Western Railway ceased passenger service into Winston-Salem in March 1961. (Courtesy of Virginia Tech Library.)

On the Cover: This is the station at Tazewell, Virginia, in the 1920s. (Courtesy of Virginia Tech Library.)

IMAGES
of Rail
NORFOLK AND WESTERN RAILWAY STATIONS AND DEPOTS

C. Nelson Harris

ARCADIA
PUBLISHING

Published by Arcadia Publishing
Charleston, South Carolina

Printed in the United States of America

Library of Congress Control Number: 2009932619

For all general information contact Arcadia Publishing at:
Telephone 843-853-2070
Fax 843-853-0044
E-mail sales@arcadiapublishing.com
For customer service and orders:
Toll-Free 1-888-313-2665

Visit us on the Internet at www.arcadiapublishing.com

To Susie

CONTENTS

ACKNOWLEDGMENTS

I am most grateful to Jane Wills at the Digital Library and Archives of the Virginia Tech Library in Blacksburg, Virginia. The library houses the collection of vintage Norfolk and Western Railway photographs, and all images used in this book come from there. I am also appreciative of the fine collection of books and other materials located in the Virginia Room of Roanoke City's Main Library and the assistance and friendliness of the staff there. I am also indebted to the outstanding Web site of the Railroad Station Historical Society for some of the information used in the captions of this work.

INTRODUCTION

For nearly a century, the Norfolk and Western Railway (N&W) served communities primarily in North Carolina, Virginia, Ohio, and West Virginia before the railway's merger with the Southern Railway to form the present-day Norfolk Southern Corporation.

The N&W emerged from the defunct Atlantic, Mississippi, and Ohio Railroad (AM&O), which had been formed in 1870 by the consolidation of three smaller railroads—the Norfolk and Petersburg, the Southside, and the Virginia and Tennessee.

The N&W began when Clarence Clark of Philadelphia purchased the bankrupt AM&O at an auction in Richmond, Virginia, on February 10, 1881, for a bid of $8,505,000. Shortly thereafter, Clark and his brothers changed the name of the railroad to the Norfolk and Western for reasons not clearly known.

For the first several years, the N&W hauled mostly cotton and other agricultural goods, but a decade later, with the development of the coal reserves of West Virginia, the N&W began to haul primarily "black gold." With that, the railway began its expansion and storied history as one of the great railroads of the American East.

To begin the history of the N&W, one needs to do some "railroad genealogy." The N&W's earliest predecessor was the City Point Railroad. This railroad was chartered in 1836 by the Virginia Legislature and opened on September 7, 1838. This date marked the "birth" of the N&W as, in 1938, the N&W would officially celebrate a "Century of Service." The City Point was a small but important rail line, being a 9-mile line from City Point along the James River to Petersburg, Virginia. City Point marked the point along the James where sailing vessels had to stop because of narrow and shallower waters, leaving Petersburg some distance away. The building of the rail line, therefore, allowed cargo to continue to be moved. The City Point Railroad actually became involved in some nonrailroad transportation enterprises along the James River as well. For a variety of economic reasons, the City Point Railroad had to be reorganized, and in 1847, the line was acquired by the City of Petersburg and became known as the Appomattox Railroad. The Appomattox Railroad was then purchased from the city in 1854 by the Southside Railroad, which was looking to have a line to City Point.

The Southside Railroad was chartered by the Virginia Legislature in 1846 for the purpose of building a rail line from Petersburg east to what is now Blackstone, Virginia. It was called Southside because it was to run south of the James River. At about this same time, in 1849, another railroad was chartered, the Petersburg and Lynchburg Railroad, for the purpose of building a line linking those two cities. The two railroads were, in 1850, chartered to form one railroad, the Southside. By late 1854, the Southside was completed, running some 123 miles.

During this same time period but unrelated to the activities of the Southside enterprise, business leaders in Norfolk, Virginia, were deeply concerned that economic opportunities for them and their community were being lost to other regions and ports. Thus, after one failed attempt, the Commonwealth of Virginia granted a charter for the Norfolk and Petersburg Railroad (N&P).

Among those drawn to this development was William Mahone, a railroad engineer and later a Civil War officer, whose name would be associated with N&W. Mahone's successful design of a track bed across the Dismal Swamp was unique for its day and contributed greatly to the development of the Norfolk and Petersburg. The N&P was completed on September 1, 1858, and was one of the most expensive railroads to be constructed during that era.

While Norfolk and Petersburg were getting their railroads, Lynchburg was continuing to struggle with rail service, though there had been many attempts. After much lobbying, however, a charter was granted for the creation of the Lynchburg and Tennessee Railroad in 1836. The hope was to link up with other planned railroads in Tennessee. Ultimately this ended in failure, continuing a frustrating pattern. In 1849, with the same goals in mind, the charter for the Virginia and Tennessee Railroad (V&T) was issued. An elaborate ceremony on January 16, 1850, marked the official start of the railroad in Lynchburg. For the next few years, the V&T engaged in construction of its line, with progress being reported by the various newspapers of the day. Finally, by 1861, the V&T line was completed, but war was imminent.

E. F. Pat Striplin, in his work, *The Norfolk and Western: A History*, succinctly describes the Civil War's influence as follows: "The impact of the Civil War on the three small predecessors of the present Norfolk and Western was catastrophic." Not only were the lines routinely attacked by Union forces, but the Confederate government paid very little reimbursement to the railroads for use of their lines and equipment to move men and material. By war's end, the rail infrastructure in Virginia was severely disrupted, and the finances of railroads were in shambles. To prevent the small railroads from being taken over by Northern investors, namely the Baltimore and Ohio Railroad (B&O), consolidation became a key strategy. On April 18, 1867, the Virginia Legislature passed the Southside Consolidation Act, at the behest of William Mahone and others, resulting in the merger of the Norfolk and Petersburg, the Southside, and the Virginia and Tennessee Railroads. While this was necessary, Mahone had a legion of critics who were wary of this new venture. Mahone immediately set out to rebuild the roads of the three lines, attract new investors (keeping those from the North a secret), and to create a rail network that could effectively rival the B&O. Within a few years, Mahone had increased the receipts of all three rail lines. Thus, in 1870, the three lines were consolidated into one enterprise—the Atlantic, Mississippi, and Ohio Railroad (AM&O). Mahone's detractors, who accused him of being a monopolist, wryly claimed that AM&O really stood for "All Mine and Otelia's." Otelia was Mahone's wife.

The AM&O would not have a long life. A national financial panic in 1873 crippled the railroad as it did numerous large business ventures in the United States. Mahone did his best to stave off his European creditors, but eventually the AM&O went into receivership. By 1880, the railroad was bankrupt and was sold the following year at auction in Richmond, Virginia, as described at the beginning of this narrative. Mahone would go on to serve as a U.S. senator from Virginia but others would lead a new rail venture that would become the Norfolk and Western.

With the Clark brothers' purchase of the bankrupt AM&O in 1881, attention can be turned to the Shenandoah Valley to complete the early history of the N&W. In 1870, a group of Philadelphia investors chartered the Shenandoah Valley Railroad as a means of tapping into the mineral resources of the region and of making various rail connections throughout the valley. By 1881 the line was operating from Hagerstown, Maryland, to Waynesboro, Virginia. Frederick Kimball was president of the Shenandoah Valley Railroad and was the chief operating officer of the newly acquired AM&O's assets, which had been renamed and reorganized as the N&W. By 1881, it was evident that the railroads would connect. Through the quick and yeoman efforts of the civic and business leaders of Big Lick, Virginia, efforts were made to lobby Kimball and others to make that connection at their community. Kimball was apparently impressed, and that location was selected. One small matter needed to be addressed, however, in that railroad officials were unimpressed by the town's name and asserted it be changed. The citizens of Big Lick voted to name their community "Kimball" after Frederick Kimball, but he declined the honor. It was suggested that it be named "Roanoke" and it was. Headquarters for the Shenandoah Valley Railroad were then moved from Hagerstown to Roanoke, and the headquarters of the old AM&O (now N&W) were

moved from Lynchburg to Roanoke. Ultimately, the Shenandoah Valley Railroad was acquired by the N&W, becoming its Shenandoah Division, and the N&W moved its attention to the coal fields of West Virginia.

In May 1881, Kimball and others headed for West Virginia to see for themselves the outcroppings of coal that had been reported. According to historians, Kimball arrived at what would become the Pocahontas coal field, took a pen knife and carved a chunk of coal from a surface vein, and stated, "This may be a very important day in our lives." By late 1882, the N&W began work to extend its New River line to that location, where mining had begun that January. And the rest, as they say, is history!

The remaining chapter introductions provide a brief history of the N&W's presence in the various states and regions it served, so that will not be covered here. Nonetheless, the N&W's early history is one of energetic, sometimes eccentric, personalities, failed ventures, Civil War, acquisitions, and politics—a strong brew that ultimately led to the creation of a storied company.

Along the lines of the N&W, depots created small towns, and small towns became cities. This book contains approximately 200 images of the old depots and stations that dotted the lines of the N&W. Some of the structures still remain, albeit for different purposes, while most have long since been razed and are now slipping into the mists of history. Aside from being vintage photographs of old buildings, the depots and stations of the N&W remind us of a bygone era, when the rail depot often marked the economic vitality and social connection of a community with the outside world. It was from the railway station that men kissed girlfriends, wives, and mothers goodbye on their way to a world war and returned to a cheer and a hug, if they returned. It was from the depot that mail was transferred, freight transported, and passengers received. While much has changed in that regard, the railroad stations and depots remind us of a time in our region's and nation's history when rail was king.

For many years, the N&W operated passenger service, and the stations and depots shown in this book underscore that service provided by the railway. At its zenith, in World War II, the N&W carried nearly 3.5 million passengers annually, but from 1946 to 1971, the passenger count dropped some 90 percent to about 350,000 in the final year of the service. Passengers boarded trains called the *Powhatan Arrow*, the *Pocahontas*, the *Tennessean*, and the *Cavalier*. Sleeping cars were named after counties and colleges served by the railway, and meals were served on special ornate china now coveted by collectors. As passengers declined, the N&W began to phase out the service beginning in the late 1950s and then altogether on May 1, 1971, when passenger service was absorbed by Amtrak.

This book of historic photographs seeks to convey some sense of the variety of depots and stations along the tracks of the N&W and the communities, both large and small, that the railway served. This is by no means an exhaustive compilation of all the structures and is not intended to be "research" per se, as other well-documented works have been produced detailing station construction and design, passenger service, and the overall history of the N&W itself. Rather, this book is for the enjoyment of those who wish to travel back in time and relish archival images of a vanished era.

The book's chapters have been divided by geography, specifically states, as opposed to the divisions of the N&W to make finding a particular depot or community easier for the reader. As those familiar with the N&W know, the railway was divided into four divisions: Scioto, Shenandoah, Norfolk, and Winston-Salem. These divisions and their various branches served communities in six states—Virginia, West Virginia, Ohio, North Carolina, Maryland, and Kentucky, with relatively few being in the last two named states. Information in the captions comes primarily from three sources: descriptions provided by the N&W with the image itself, Striplin's *The Norfolk and Western: A History*, and from the Web site of the Railroad Station Historical Society, where enthused members have reported the status of some of the stations herein included. It should be noted that all of the images come from the Digital Library and Archives at Virginia Tech, and as such, all courtesy credits reside with them. The original images (Tech has the digitized images of the originals) and the historical papers and documents associated with the N&W and

its variously acquired railroads now reside in the archives of the Norfolk-Southern Corporation in Atlanta, Georgia.

This book, as with my previous Arcadia title on the N&W Railway, was of personal interest to me in that the N&W was headquartered in my hometown of Roanoke, Virginia. In fact, Roanoke owes much of its development and history to the railway. Roanoke was chartered in 1882 when the N&W decided to make the town of "Big Lick" its headquarters and thus prompted (thankfully!) name change for the place. The railway's presence caused Roanoke to be one of the most rapidly growing cities in population in the American South for almost 30 years, from 1882 until 1912 earning it the moniker the "Magic City." Today the N&W still occupies a significant economic presence in the Roanoke region. On a personal note, my father worked most of his career for the N&W Railway, and I was pleased to dedicate my previous title to him.

—Nelson Harris
Roanoke, Virginia
July 2004

One

WEST VIRGINIA

The Norfolk and Western Railway first entered West Virginia on May 21, 1883, with the completion of its then New River Division, which ran from the New River through the southwestern part of Mercer County and into the coal fields at Pocahontas, Virginia. It should be noted that the first car of coal produced on the N&W was loaded at Pocahontas on March 12 of that same year.

By late 1883, the N&W was hauling large amounts of coal out of West Virginia to Norfolk, Virginia. This enterprise was significantly enhanced with the construction of the Elkhorn Tunnel through Flat Top Mountain in 1886, allowing the railroad's expansion on the west side of the mountain. A line reaching to Welch was completed in 1892. The N&W's presence in West Virginia was furthered by the purchase of the Scioto Valley Railroad in 1890. The N&W went to great lengths to create a rail infrastructure to develop the coal fields of southern West Virginia, often employing foreign-born workers, some of whom remained in the areas to work the mines. Among the branches completed or extended during this period were the North Fork (1894), Briar Mountain (1902), Crane Creek (1903), Tug Fork to Gary (1904), Clear Fork (1905), Widemouth (1905), Dry Fork (1906), Spice Creek (1909), Poplar Creek (1909), and Sycamore (1911). Another major venture of the N&W was the electrification of the line between Bluefield and Kimball, known as the "Elkhorn Grade Electrification." This project was completed in the spring of 1915 and included 106 miles of track. By 1920, there were four major coal fields being served by the N&W—Pocahontas, Tug River, Thacker, and Kenova—producing a volume of 23.6 million tons of coal being transported from them by the railroad that year.

From 1900 to 1920, the presence of the N&W dramatically changed many of the towns and villages in the mountain valleys of West Virginia. Bluefield, which became known as "the gateway to the Pocahontas coal field" and saw its population boom from 600 in 1890 to 11,180 by 1910, is one such example.

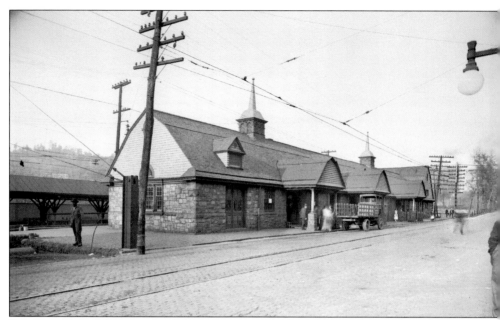

BLUEFIELD. This photograph of the passenger station was taken on September 25, 1917. The station was later remodeled in 1941. Unfortunately, the structure no longer stands. Bluefield was known as the gateway to the Pocahontas coal field and was transformed by the railroad's arrival. From 1890 to 1910, its population went from 600 to more than 11,000.

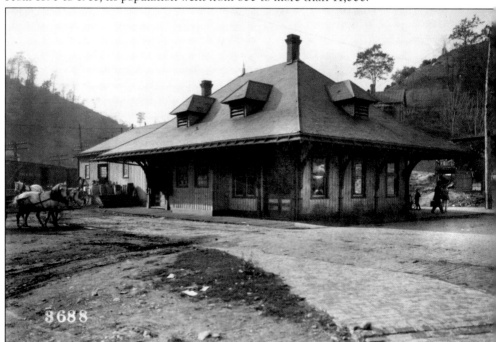

BRAMWELL. This c. 1920 image shows the original station at Bramwell. Though the station was demolished in the 1950s, the town now has a reconstructed depot that opened in November 2002 that houses a museum and visitor's center. At one time, Bramwell was home to coal barons and boasted the most millionaires per capita than any other city or town in America.

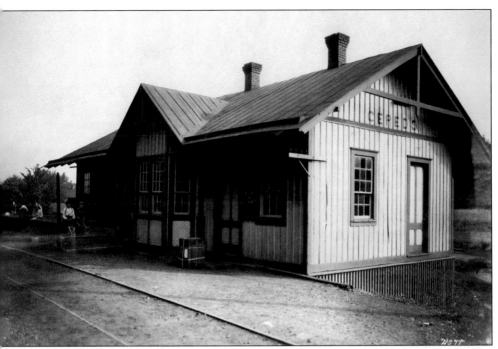

CEREDO. This image shows the station as it looked in 1915. The town is located in Wayne County and was founded in 1857 by a Massachusetts congressman, Eli Thayer, as a free colony in slave-holding territory. The name is derived from Ceres, the goddess of growing vegetation. The depot was located on the Williamson and Kenova Branch of the Scioto Division.

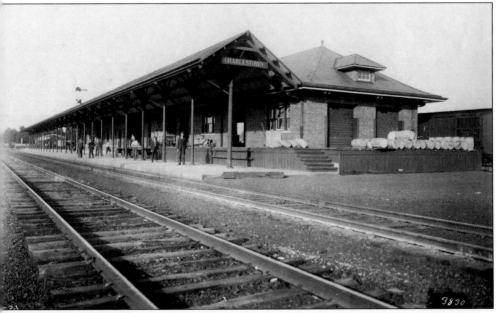

CHARLESTOWN. Pictured here is the combination station, which still stands, in 1915. Charlestown is located in the northeastern panhandle of West Virginia and was part of the Shenandoah Division of the Norfolk and Western Railway, whose line ran north from Roanoke, Virginia, to Hagerstown, Maryland.

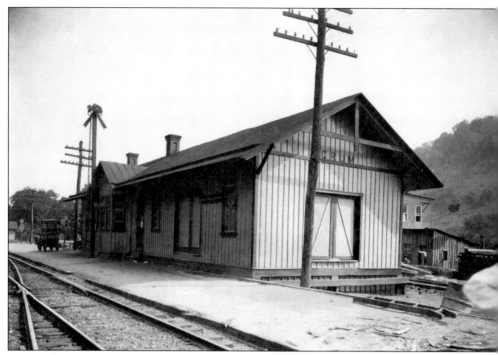

CRUM. The station is pictured as it appeared around 1915. Crum is located between Kermit an Welch in Wayne County. In the 2000 census, the population of the town was 300. Crum is locate along Route 52 and is bordered on the west by the Tug Fork of the Big Sandy River.

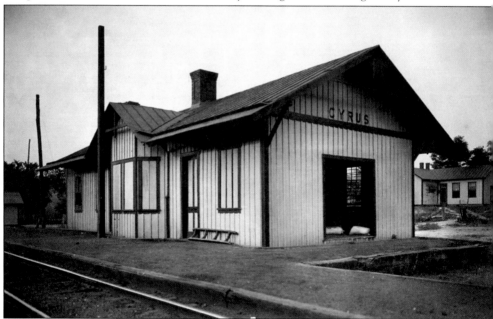

CYRUS. The station, pictured around 1915, is part of the Williamson and Kenova Branch. Cyru is located along the Ohio River in Boone County. As a historical footnote, coal shipments from the Kenova/Clinch Valley region topped 700,000 tons in 1898, a record for that time during th N&W's development of its coal enterprise.

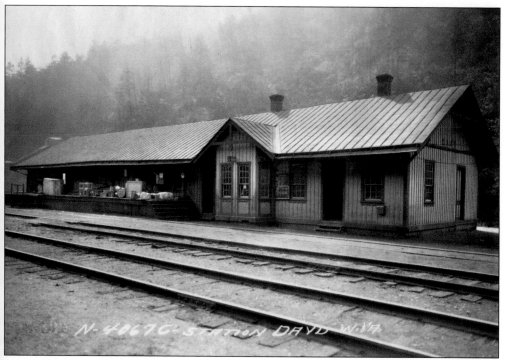

Davy. Located in McDowell County, Davy was formerly named Hallsville until 1903. Its name was changed at that time because of the town's location along the Davy Branch, a nearby stream. This images dates from around 1915.

Delarme. The station is pictured around 1915. Delarme is located in Mingo County and was in the Thacker Coal District. Mingo County was the most recently created county in the state (1895) and is named for the Mingo Indian people of that area.

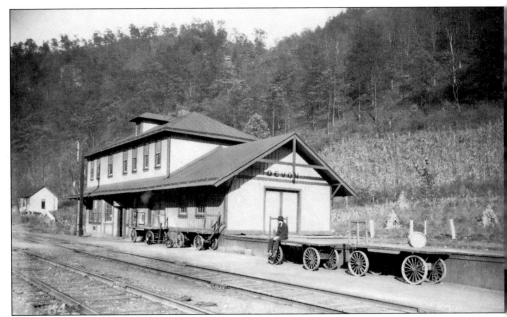

DEVON. The Norfolk and Western Railway arrived in Devon, located in Mingo County, in 1891. Upon the railroad's arrival, the name of the town was changed from O'Keefe to Devon. The above image shows the station as it appeared around 1915. In that year, more than 11,000 passengers came through the station.

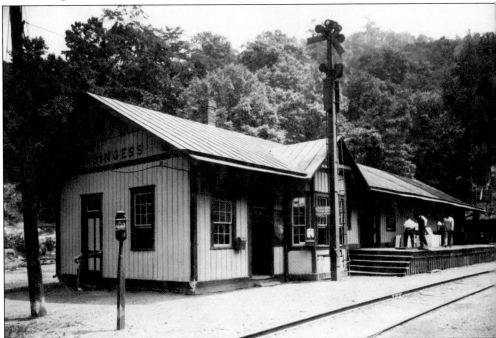

DINGESS. The town was named for William Dingess, a German, who was the first recorded settler in the area. Dingess is located in Mingo County, and the image above dates from around 1915. Dingess was a critical point for the railroad along the Ohio River for moving high-quality coal to Kenova for shipment down the Ohio by barge.

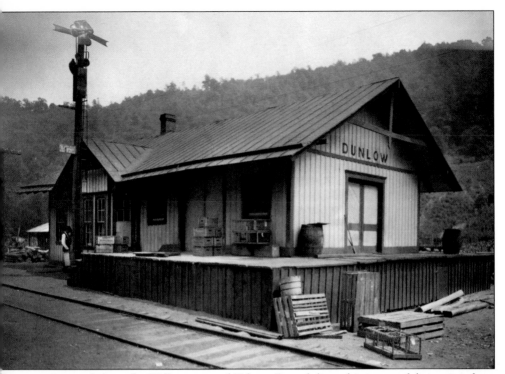

DUNLOW. Located along the Williamson and Kenova Branch line, this image of the station dates from around 1915. The structure still stands. The community is located in Wayne County on Twelvepeople Creek. It was created as a town when the N&W moved north toward Ohio in 1892. It is most noted for a circus train accident there in the 1940s in which several animals escaped and were never captured.

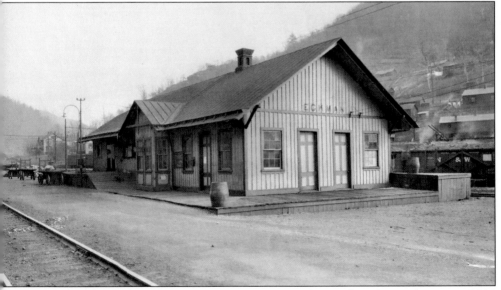

ECKMAN. The above image shows the station as it appeared around 1915. In 1920, some 16,000 passengers came through on the trains. Eckman's passenger traffic began to steadily decline shortly thereafter. The Eckman station was a stop located between Keystone and Kimball.

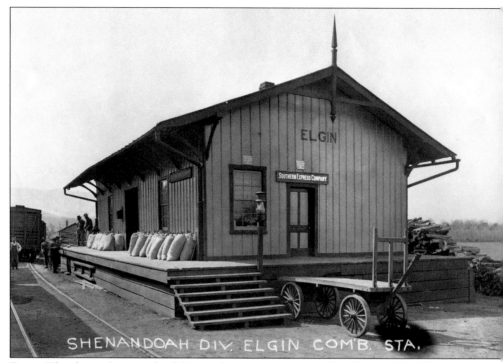

ELGIN. The above photograph of this combination station was dated around 1915. Elgin is located just north of Luray, Virginia, and was on the Shenandoah Division line of the N&W. This line had originally been a part of the early Shenandoah Valley Railroad.

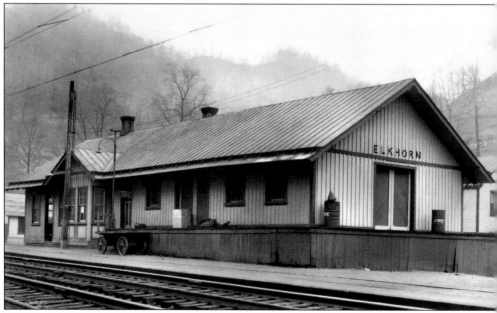

ELKHORN. Located in McDowell County, Elkhorn supposedly got its name because a hunter having slain a large elk, stuck its horn upon a pole at the mouth of the creek. The image of the station is dated January 7, 1933. From 1886 (the year the tunnel was completed through Flat Top Mountain) until 1892, Elkhorn was the principal station in the county.

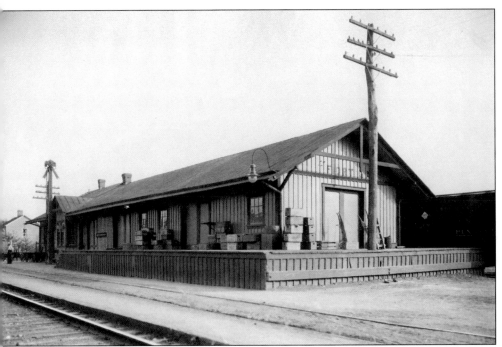

FORT GAY. Located in Wayne County, the town is located at the junction of the Tug Fork and the Big Sandy River. It was named for a Civil War fort that stood on a hill overlooking the village below it. The image of the station is from around 1915. In 1912, some 17,000 passengers were served by the station.

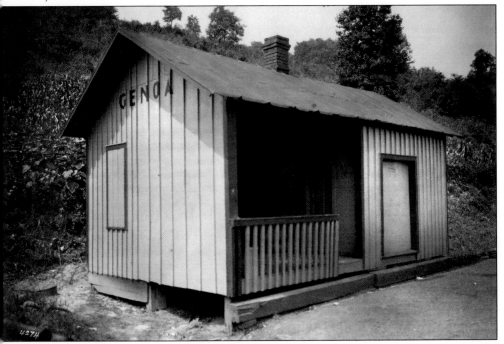

GENOA. This small town is located in Wayne County and was named for Genoa Reed, who was the daughter of an early postmaster in the area, E. P. Reed. The image above is dated around 1915.

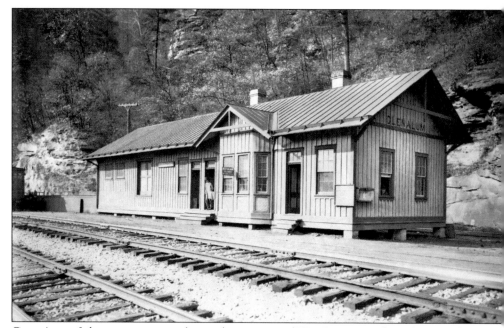

GLEN ALUM. Like many towns in the southern region of West Virginia, Glen Alum was developed around the coal industry. Located in Mingo County, the town was named for the Glen Alum Coal Company. The above image is dated around 1920.

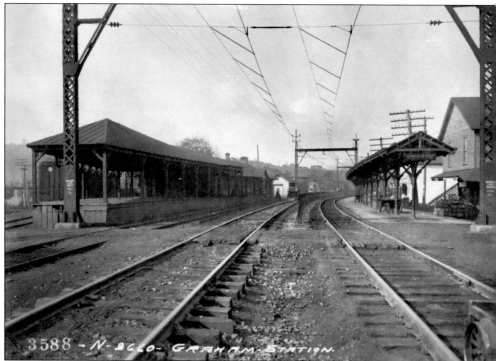

GRAHAM. Located near Bluefield in Mason County, Graham was named for the Reverend William Graham, a Presbyterian minister, who tried to start a settlement in the area in 1798. The image of the Graham station is dated from around 1915.

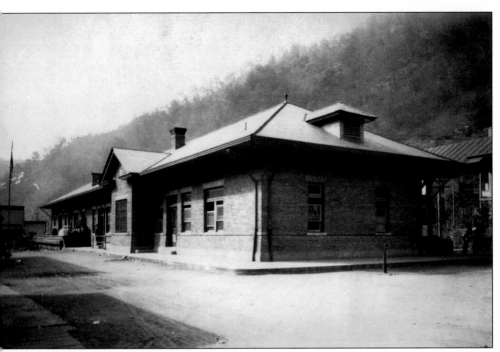

AEGER. Located in McDowell County, Iaeger was originally a stop on the old Iaeger and Southern Railroad, a line used by the timber industry. Iaeger was part of the "new" electrified line of the Norfolk and Western running between Bluefield and Iaeger in 1914. The above image is undated.

KENOVA. Kenova is located in Wayne County along the Ohio River and was founded in 1889. The name Kenova is derived from a compound abbreviation of the names of the states of Kentucky, Ohio, and West Virginia, as this is the point where the three states converge. The above image of the Kenova station is dated around 1915.

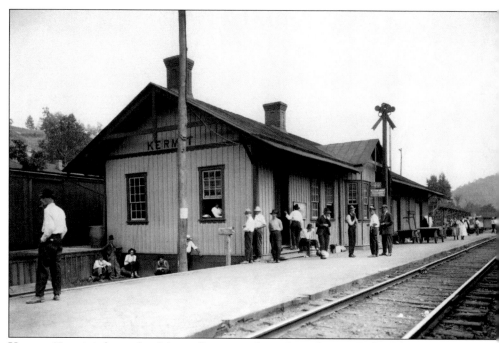

KERMIT. Kermit is located in Mingo County and sits along the Tug Fork of the Big Sandy River. Formerly known as "Warfield," the name was changed to Kermit in 1906 in honor of the younges son of Pres. Theodore Roosevelt. The above image of the station dates to about 1915.

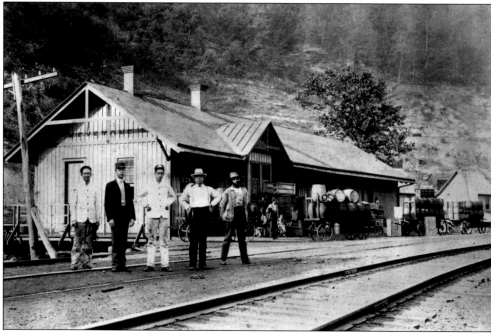

KEYSTONE. Formerly known as Cassville, the town was renamed by the Keystone Coal and Coke Company because its Mine No. 1 was there. Located in McDowell County, the town's station is shown as it looked around 1915. At that time, Keystone was the largest town in the county, having been incorporated in 1909.

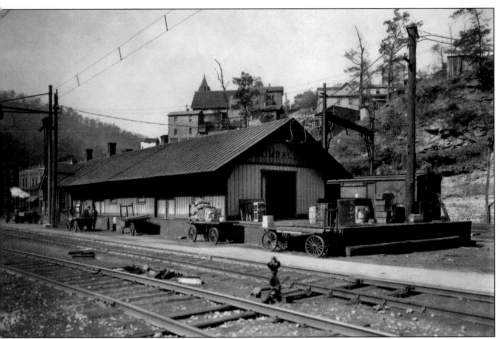

KIMBALL. The town of Kimball, located in McDowell County, was incorporated in 1911 and was named for the late president of the Norfolk and Western Railway, Frederick J. Kimball. Interestingly, Roanoke, Virginia, had tried in 1882 to name itself after Kimball, but he suggested it be called Roanoke. The above image of the station is from 1920.

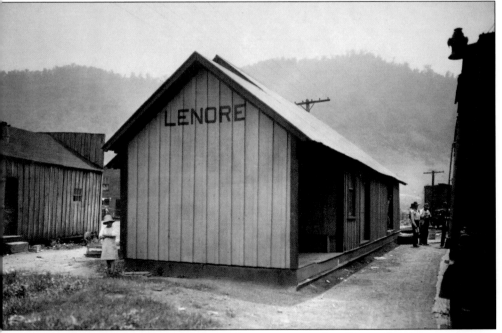

LENORE. In 1920, a branch line of the railroad was constructed up Pigeon Creek from Lenore in Mingo County for some 18 miles in order to develop a new coal field previously unreached by the railroad. The above image of the station at Lenore dates from this same period.

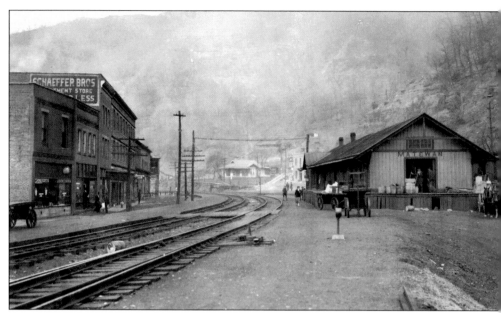

MATEWAN. Located in Mingo County, Matewan is situated along the Tug Fork. Incorporated in 1895, it was named for Matewan, New York, home of the engineer who originally surveyed the town. Matewan is most famous for a notorious shoot-out that occurred there on May 19, 1920, which was just a few years later than the date of the above image. The original station no longer remains, though a duplicate was later constructed.

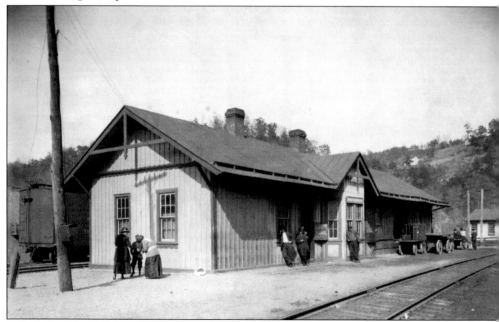

MATOAKA. This November 1918 image shows the town's station, which still stands. It was also associated with the Virginian Railway. Located in Mercer County, the town was incorporated in 1903 and derives its name from a Native American term that also means "Pocahontas." This station was located along the Bluestone Branch of the N&W. Passenger service ended on this branch in 1953.

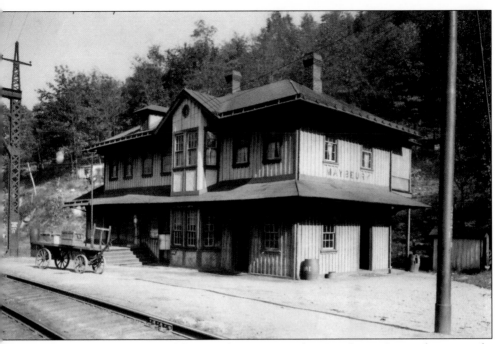

MAYBEURY. This town was named for a coal operator's wife, Mary Beury. It was the scene of a tragic train accident on June 30, 1937, when a 468-ton locomotive and its 40 cars plunged from a 100-foot-high trestle, killing four people. The image of the station is from 1915. At that time, "Charley" Duff was the stationmaster there, a position he held for nearly 30 years.

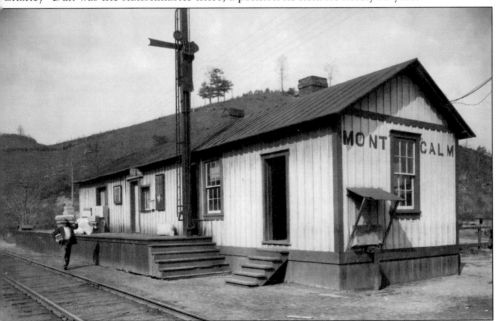

MONTCALM. The image of the station is from 1920. Montcalm is located in Mercer County, which was founded in 1863 when West Virginia ceded from Virginia during the Civil War. Montcalm is located near Bluefield and had a population of 885 in the 2000 census. Montcalm was a part of the Bluestone Branch of the N&W. Passenger service ended on this branch in 1953.

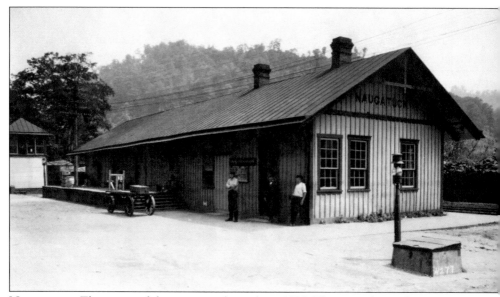

NAUGATUCK. The image of the station is from about 1920. The town, located in Mingo County along the Tug Fork, was originally platted in 1892. The name is from a Native American term meaning "forks of the rivers."

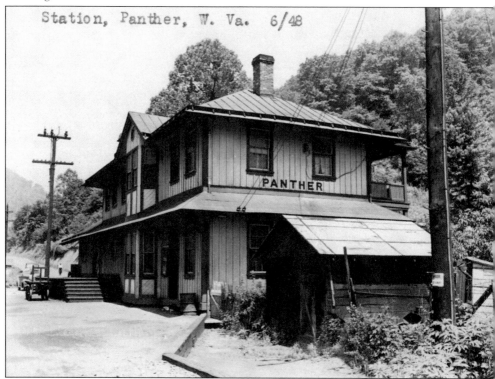

Station, Panther, W. Va. 6/48

PANTHER. Located in McDowell County, Panther gets its name from a nearby creek. The above photograph of the station is from June 1948. Situated between Glen Alum and Iaeger, Panther was a small mining community, like most in the region. At one time, the N&W had more miles of track in McDowell County than in any other jurisdiction within its system.

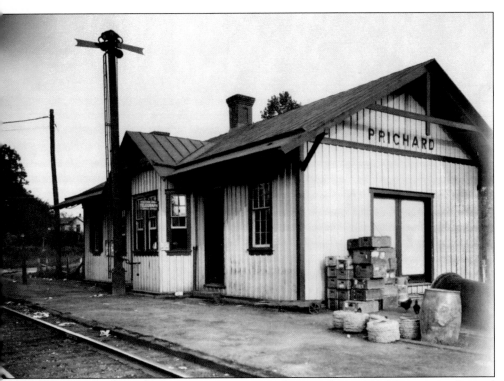

PRICHARD (WHITESVILLE). This image of the station dates to about 1920. This town is located in Boone County along the Big Coal River. It was incorporated and renamed "Whitesville" on August 15, 1935, for B. W. White, an early settler. It was also known as Jarrod's Valley.

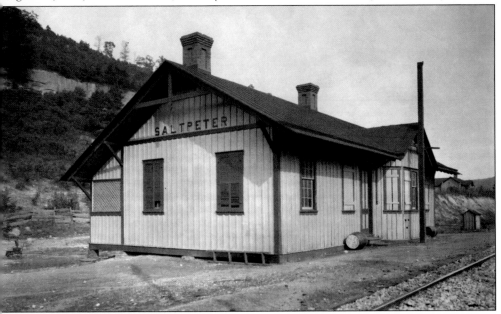

SALTPETER. Named for the saltpeter industry, the town is located in Wayne County. The above image is from about 1920. Saltpetre was in the N&W's Kenova District and is one of many unincorporated communities in the county.

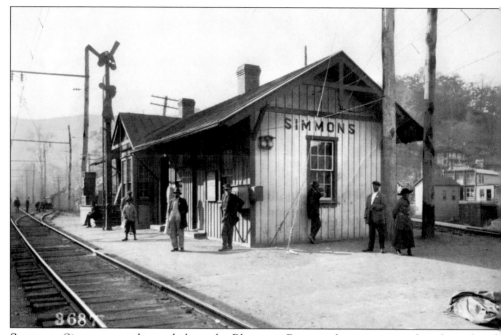

SIMMONS. Simmons was located along the Bluestone River and was connected to the railroad Bluestone Junction. It was in the "Elkhorn Grade Electrification" region, where rail lines were electrified in 1915, a region that at the time consisted of about 106 miles of main tracks, sidings and branches. The above image is from 1915.

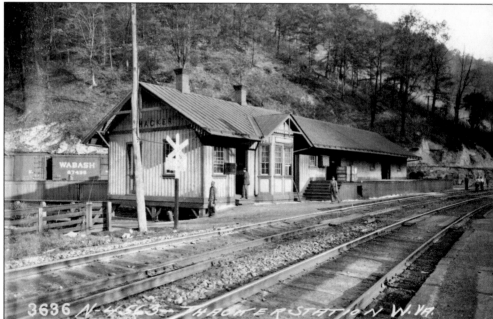

THACKER. Reuben Thacker made the first settlement here, remained a few years, giving the creek its name, and then continued moving west. Thacker is located in Mingo County, and the above image of the town's station dates to about 1915. Mingo County is considered to have one of the richest coal reserves in the state.

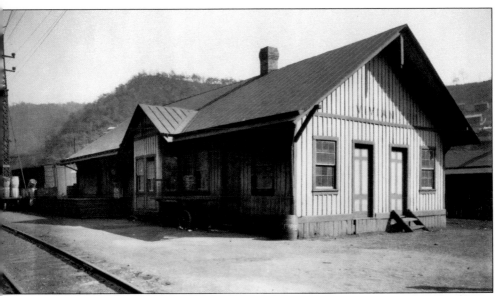

VIVIAN. Originally known as "Clausen," the town in McDowell County was later called the "Vivian Yard" by the Norfolk and Western Railway. Then, over the years, its name became shortened. The image of the station as shown above dates to about 1920. This point was located on the rail line between Bluefield and Kimball.

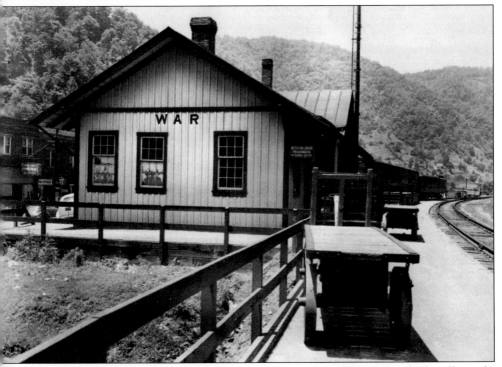

WAR. This June 1948 photograph shows the station in McDowell County, which still stands. Known originally as "Miner's City," the Norfolk and Western Railway changed the town's name in 1904 when it erected a station there. On the station's exterior, it painted the sign "War," denoting the nearby creek. That changed the name.

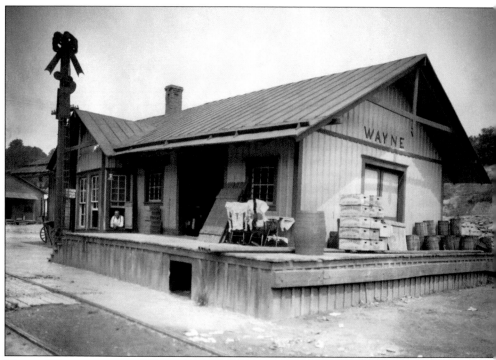

WAYNE. The county seat of Wayne County, the town was formed as "Trout's Hill" in 1842, named after Abraham Trout. The name was later changed in honor of American Revolutionary War hero Gen. Anthony Wayne. The image of Wayne Station dates from about 1920.

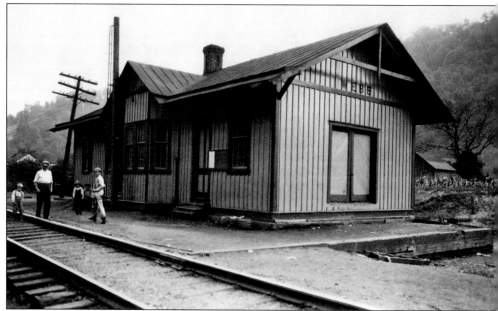

WEBB. Webb is located in Wayne County between Fort Gay and Crum. This image is from around 1920. Wayne County was in the N&W's Kenova District. Named for Gen. Anthony Wayne, who defeated the Shawnee in the area, the county was not created until 1846 and is the westernmost county in the state.

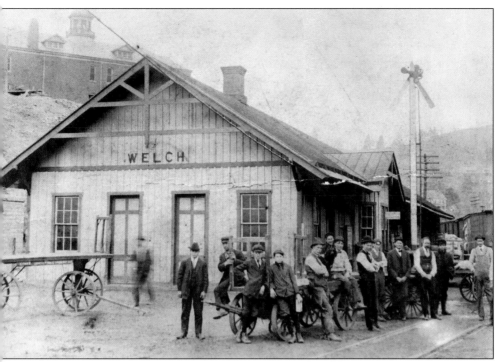

WELCH. Located in McDowell County, Welch was incorporated in 1894, a few short years after the arrival of the Norfolk and Western Railway there in 1891. This 1908 image shows the station, and now only the freight depot still stands. By the 1950s, McDowell County had some 50 coal operations in production.

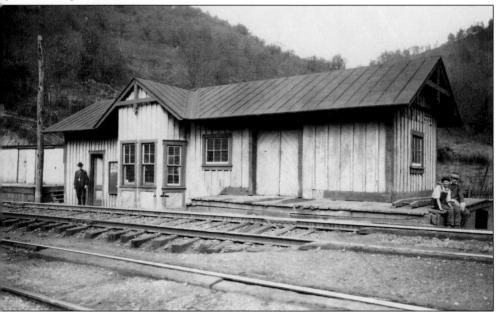

WHARNCLIFF. Located in Mingo County, Wharncliff's station is pictured around 1915. Mingo County was part of the N&W's Ohio extension in the 1890s, which proved quite profitable by providing the shortest distance for transporting coal from that region to an East Coast port (Norfolk).

WILLIAMSON. The above image shows the Williamson station as it looked in July 1950. The structure still remains and is currently in municipal use. Williamson is the seat for Mingo County and was named for Wallace Williamson, the original owner of the town's site. The railroad arrived in Williamson in 1892.

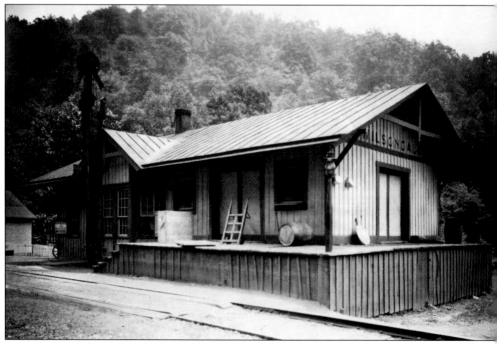

WILSONDALE. The Wilsondale station still stands and is used today by a private business. The above image shows the station as it looked in 1920. The town is located in Wayne County and was in the N&W's Kenova District.

Two

VIRGINIA

The presence of the N&W in Virginia dates back to the inception of its predecessors, amply described in the introduction. For the N&W, two points in Virginia were prominent, namely Roanoke and Norfolk.

Beginning in 1882, Roanoke became the headquarters of the N&W when it decided to connect with the Shenandoah Valley Railroad at that location. This move basically created the city and spurred its dramatic growth for the following three decades. Not only did the N&W have a vast operation and shops there, but it also built and owned for several decades the famed Tudor-styled Hotel Roanoke. The Roanoke shops produced the N&W's finest steam locomotives over many decades, and two now reside at Roanoke's Virginia Museum of Transportation, the 611 and the 1218.

As for Norfolk, it became the port from which the N&W sent its coal around the world. In fact, the U.S. Navy in World War II insisted that its Atlantic fleet be serviced by N&W's coal moving constantly out of far southwestern Virginia and West Virginia. By the late 1970s, the N&W was hauling some 75 million tons of coal annually to its Lamberts Point facility.

The N&W increased its presence in Virginia with the acquisition of the Virginian Railway, a line known for its efficiency. The Virginian ran, among other places, from Princeton, West Virginia, to Norfolk. In addition to coal, it also had passenger service, which ended in 1956. The Virginian merged with the N&W in December 1959.

Another Virginia railroad purchased by the N&W was the Atlantic and Danville (A&D) in 1962. The A&D ran 205 miles from West Norfolk to Danville. The line was renamed by the N&W as the Norfolk, Franklin, and Danville.

Through both acquisitions and expansions of its lines, the N&W managed to have a significant presence in Virginia, particularly the southern half. Ultimately, its merger with the Southern Railway into the Norfolk-Southern Corporation greatly enhanced a united railroad presence in the state, but it also ended the N&W as a corporate entity. While the N&W typically constructed its early lines from town to town, it also created some along the way and renamed others, leaving a mark on the state that still remains today.

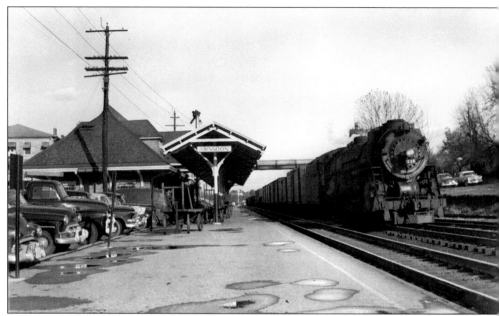

ABINGDON. This 1957 photograph by I. N. Drake shows Engine No. 115 at the Abingdon Station in Washington County. The station was built in 1910 and is currently used for municipal office and a police station. Abingdon is the seat of Washington County and home to the famed Barter Theater. It was named for the ancestral home of Martha Washington in England.

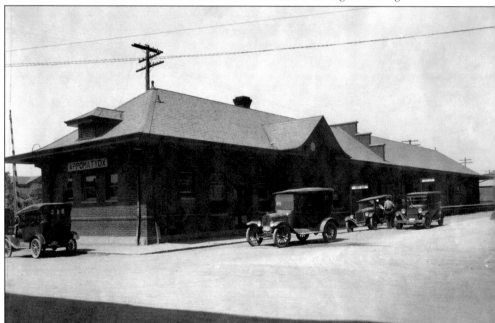

APPOMATTOX. This 1920s image is of the Appomattox station along the line of the Norfolk Division. The station still remains and is currently being used by the local chamber of commerce and as a visitors' center. The town is the seat of Appomattox County and was originally called "Nebraska," being renamed in 1895. It is approximately 3 miles from the Appomattox Courthouse where the Civil War ended.

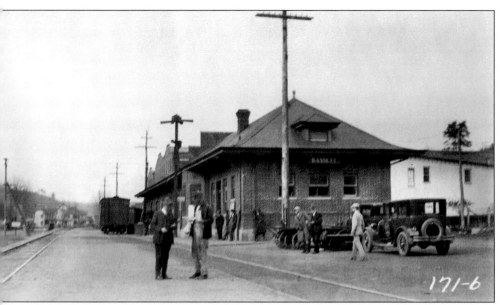

BASSETT. This image is from about 1915, and the station was along the line in the Winston-Salem Division. The structure is used for storage by the Norfolk-Southern Corporation today. Bassett is in Henry County and was home to the former Bassett Furniture Company, which was started by the Bassett family in 1902.

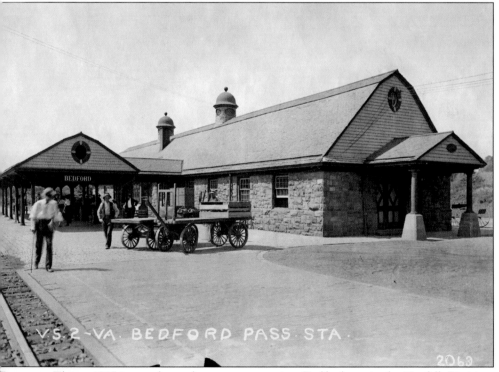

BEDFORD. This c. 1915 image shows the passenger station. Bedford was in the Norfolk Division, and the station is now used as a restaurant. Bedford is an independent city and the seat of Bedford County. It is also home to the National D-Day Memorial.

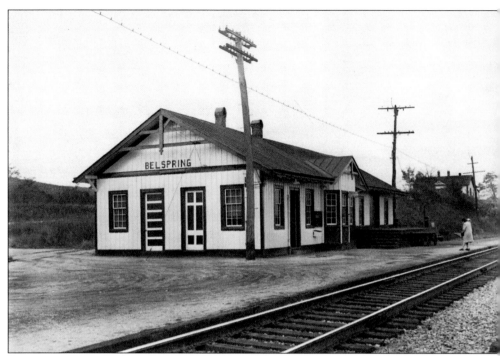

BELSPRING. This photograph was taken in October 1947. Belspring is located in Pulaski County. Pulaski County was named in honor of Count Casimir Pulaski, a Polish nobleman, who joined Gen. George Washington's Continental Army in 1777. Promoted to the rank of brigadier general, Pulaski was mortally wounded at the Battle of Savannah in 1779.

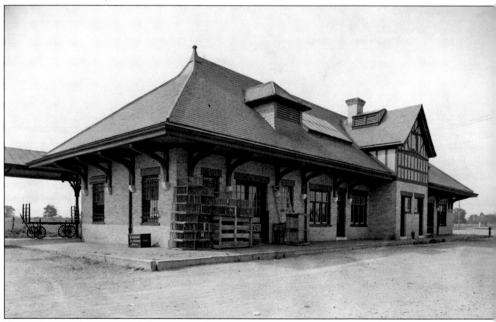

BERRYVILLE. This image of the Berryville station of the Shenandoah Division was taken around 1915. Berryville is the seat of Clarke County in the upper Shenandoah Valley. The town was established in 1798, and the first railroad reached the town in the 1870s.

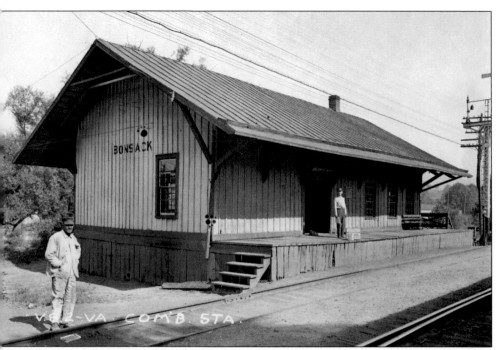

BONSACK. Bonsack is located in Roanoke County, and this c. 1915 image is of the combination station. Bonsack is along Route 460 and was named for the Bonsack family who settled there. In the 1880s, James Bonsack invented the first cigarette-rolling machine, providing him and his family great wealth. Passenger service ended in Bonsack in 1957, which had been served by Norfolk-Roanoke Accommodation Trains No. 7 and 8.

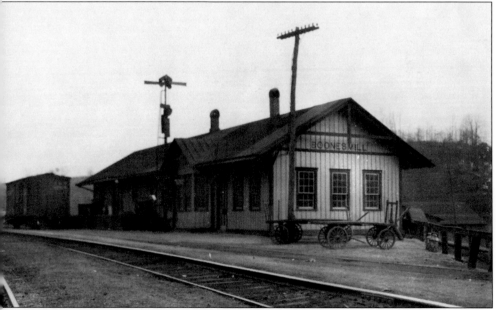

BOONES MILL. Boones Mill is located in Franklin County, and this image dates from around 1920. It was along a line in the Winston-Salem Division. The structure remains in the ownership of the Norfolk-Southern Corporation.

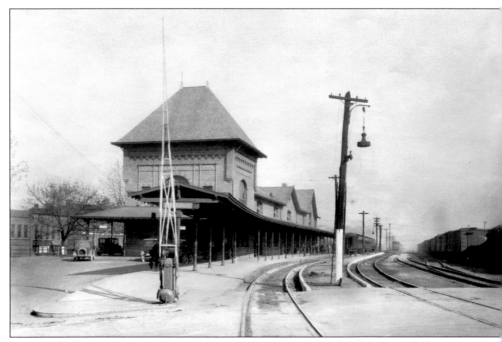

BRISTOL. Due to its location, this station served residents of both Virginia and Tennessee. Buil in 1902 by Pettyjohn and Company of Lynchburg, the station replaced an earlier freight station that had served the community. The structure still stands, having been remodeled, and is used to house a small commercial mall. This photograph dates from around 1920. The station is listed on both the Virginia and National Register of Historic Places.

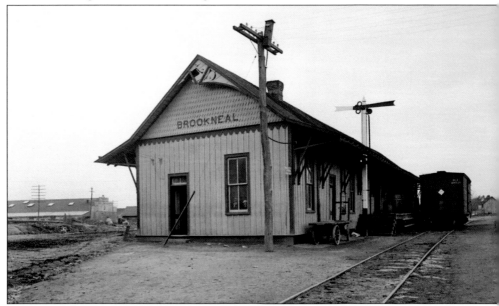

BROOKNEAL. This combination station was a part of the Durham District of the N&W. Located in Campbell County, the station is used for a commercial purpose today. This image is from March 1917. The first railroad to reach Brookneal was the Lynchburg and Durham Railroad in the 1880s. The community and station was also served by the Virginian Railway.

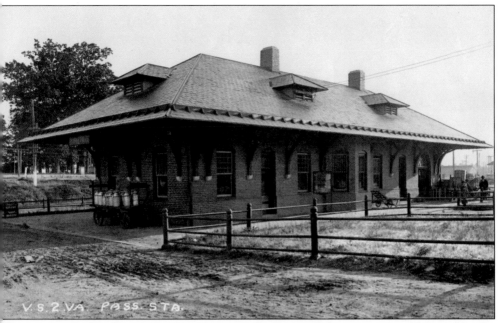

BURKEVILLE. Burkeville is located in Nottoway County, and this station was also used by the Southern Railway. Built in 1915, it has since been relocated to the town's park, where it is now used as a community center. This image was taken shortly after its construction. The N&W built a 37-mile, low-grade line from here to Pamplin, Virginia, in 1915.

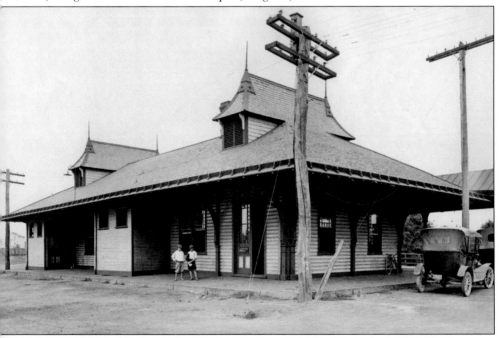

BLACKSTONE. This image shows the Blackstone Passenger Station around 1920. Blackstone is located in Nottoway County. Blackstone's station served the U.S. Army's Fort Pickett, which opened in 1941 and was a key training facility in World War II. The fort was closed in the 1990s and is used today by the Virginia National Guard.

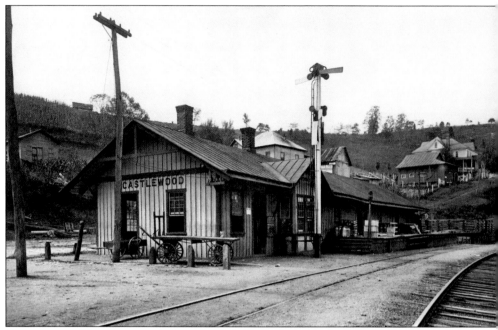

CASTLEWOOD. This photograph dates from about 1920. Castlewood is located in Russell County. Russell County was named for Col. William Russell, who assisted in the drafting of the Declaration of Independence. Originally, the seat of the county was "Castle's Wood," from whence the town derives its name, before it was moved to Lebanon.

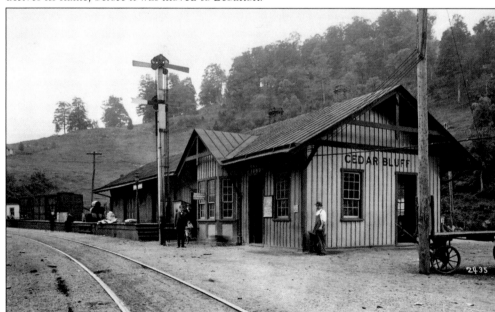

CEDAR BLUFF. This photograph dates from about 1920. Cedar Bluff is located in Tazewell County. Tazewell County was formed in 1799 and was named for Henry Tazewell, a U.S. senator from Virginia. Some opposed the creation of the county, including the late Senator Tazewell's son, who was a member of the Virginia Legislature. When it was agreed upon that the new county would be named for a family member, the son gave the new county his support.

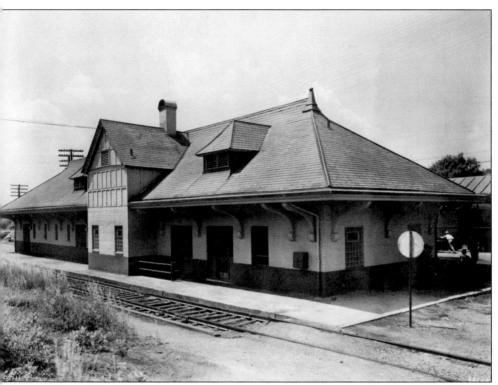

CHRISTIANSBURG. This image was taken in May 1949 and shows the Christiansburg passenger station, located in Montgomery County. The station was originally constructed in 1906 and is currently in use, though not as a passenger station, by the Norfolk-Southern Corporation.

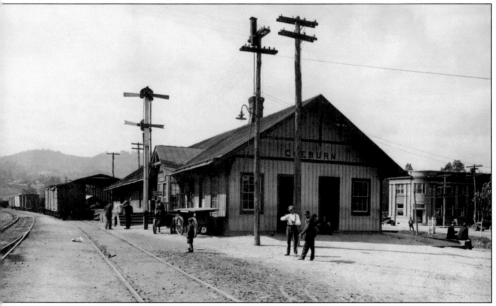

COEBURN. This c. 1920 image shows the Coeburn station in Wise County. The former combination station still stands and is used today as the town's community center. Coeburn sits along the Guest River.

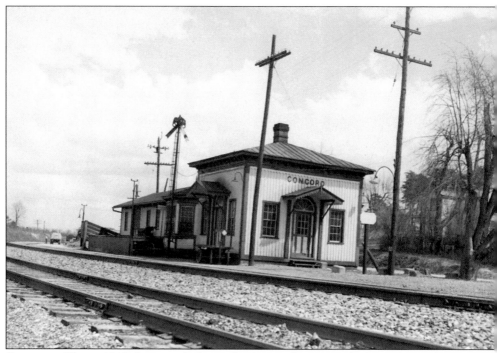

CONCORD. This c. 1945 photograph shows the Concord station, which was located just outside Lynchburg in Campbell County. G. M. Cross was the operator-agent at this time. The structure still stands and was most recently used as a private residence.

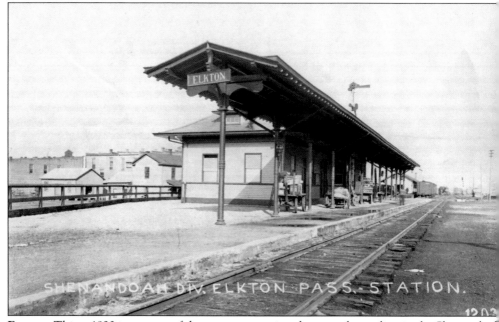

ELKTON. This c. 1920 image was of the passenger station that was along a line in the Shenandoah Division. Elkton was originally known as "Conrad's Store" and is located in Rockingham County. When the Shenandoah Valley Railroad came through in 1881, it named the depot "Elkton" after the nearby Elk Run Stream. This effectively renamed the town.

EMORY. This I. N. Drake photograph was taken in April 1976. The station now sits on the campus of Emory and Henry College and is used as an art gallery. Emory, located in Washington County, had a combination station. The first railroad reached Emory in 1856.

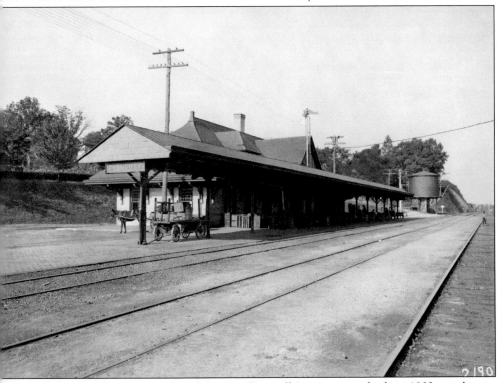

FARMVILLE. Located in Prince Edward County, Farmville's station was built in 1903 on a line in the railway's Norfolk Division. This image dates from around 1920. Today the station is restored and in use as commercial property. Farmville is home to Longwood University and nearby Hampton-Sydney College. Passenger service ended here in 1957.

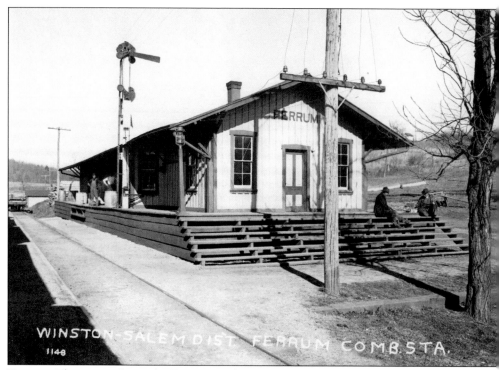

FERRUM. This image shows the Ferrum combination station as it looked about 1920. Located in Franklin County, Ferrum was on a line in the railway's Winston-Salem District. Ferrum is home to the Methodist-affiliated Ferrum College.

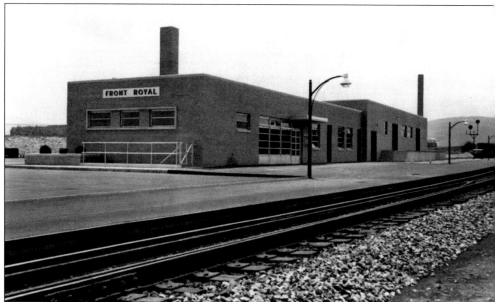

FRONT ROYAL. This c. 1950 photograph shows Front Royal's combination station, which still stands. The seat of Warren County, this was in the railway's Shenandoah Division. Front Royal was incorporated in 1788, and some believe its name derives from the days when the land was held by the king of England and the area was known then as "the royal frontier."

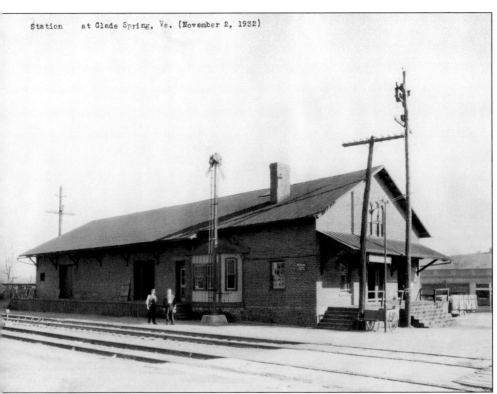

Station at Glade Spring, Va. (November 2, 1932)

GLADE SPRING. This photograph was taken in November 1932. Located in Washington County, rail lines reached Glade Spring in 1856, and the town shifted to the depot. Glade Spring was home to Virginia Intermont College until the college moved to Bristol in 1892. Today 9 miles of rail bed from here to Saltville are being turned into a hiking and biking "Salt Trail."

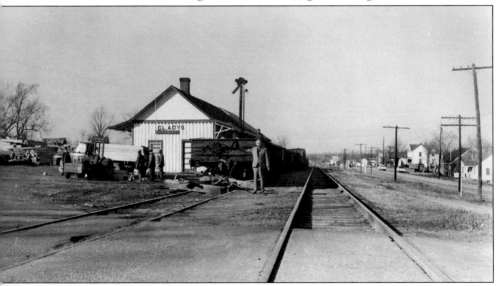

GLADYS. This I. N. Drake image was captured in January 1957. Gladys was on the N&W's line that ran from Lynchburg south to Durham (originally the Lynchburg and Durham Railroad). Gladys is located in Campbell County. Rail reached Gladys in 1888.

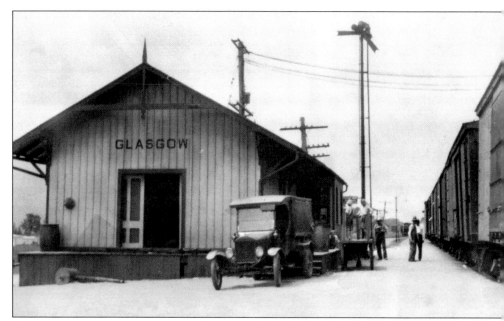

GLASGOW. Located in the railway's Shenandoah Division, this image dates from about 1920. Glasgow sits in Rockbridge County at the confluence of the James and Maury Rivers. Glasgow, like many of the towns and villages in the Shenandoah Valley region, was named by Scotch-Irish settlers for Glasgow, Scotland.

GLEN LYN. This image is from around 1920. Glen Lyn is in Giles County. Giles County was formed in 1806 and was named for William Branch Giles, a former Congressman from and governor of Virginia. Giles County is home to Mountain Lake, a popular resort area, where the movie *Dirty Dancing* was filmed.

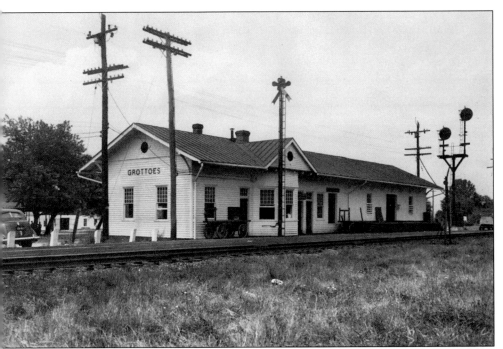

GROTTOES. This photograph was taken in August 1948. Grottoes straddles the Augusta-Rockingham county line. Rockingham County was established in 1788 and was named for Charles Watson-Wentworth, second marquess of Rockingham, England. He served twice as Britain's prime minister and actually supported the independence of the American colonies from England.

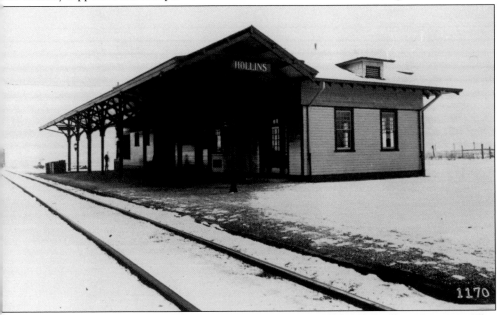

HOLLINS. Located in Roanoke County, Hollins is known for its all-female Hollins University. This image dates from about 1920. Passenger service at the Hollins station ended in the mid-1950s, and the station no longer remains. Roanoke County was established in 1838 and was named for the Roanoke River.

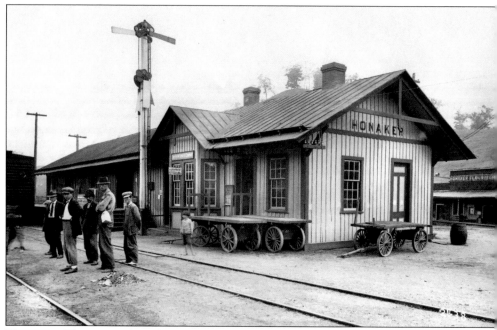

HONAKER. This image dates from around 1920. Settled as early as 1772, Honaker is in Russell County. Honaker was part of the Clinch Valley operations of the N&W. According to railroad historians, the N&W line reached Honaker in 1889, but progress was slow in the construction of the line because of topography and weather.

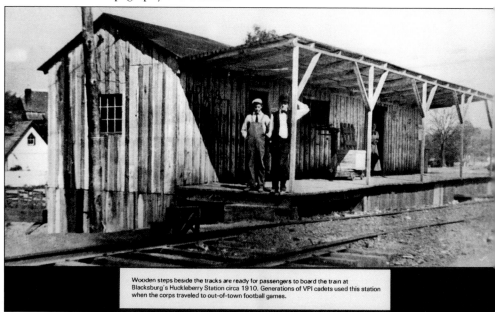

Wooden steps beside the tracks are ready for passengers to board the train at Blacksburg's Huckleberry Station circa 1910. Generations of VPI cadets used this station when the corps traveled to out-of-town football games.

HUCKLEBERRY. Huckelberry was the nickname given to the train and station at Blacksburg that served the cadets and students at the Virginia Polytechnic Institute and State University (now Virginia Tech). This image from about 1920 shows the station where generations of Tech cadets traveled often to and from football games. The name "Huckleberry" has many traditions about its origin, but most seem to connect it to the rail line's meandering, vine-like shape.

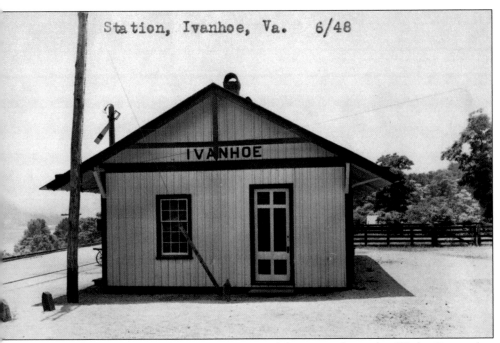

Station, Ivanhoe, Va. 6/48

IVANHOE. This photograph was taken in June 1948, and the station, located in Wythe County, has since been razed. Ivanhoe was located on a branch line of the N&W that ran south out of Draper to Galax. Other stops on that branch included Fries, Grayson, Austinville, and Allisonia.

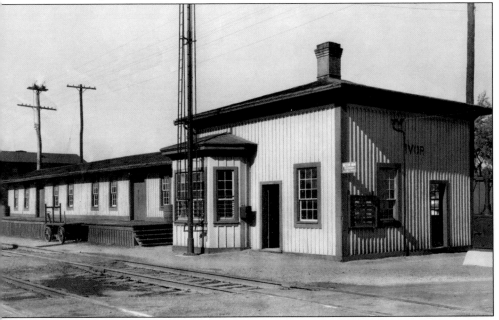

IVOR. This station and community were located between Norfolk and Petersburg. The above image dates from June 1932. A town in Southampton County, it was named when prominent railroad executive William Mahone and his wife, Otelia, traveled along the line of the newly completed Norfolk and Petersburg Railroad, naming stations. Otelia was reading the book *Ivanhoe* and took the name from a Scottish clan in the novel.

49

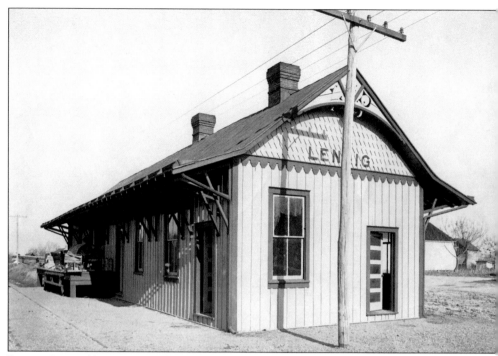

LENNIG. Located between Lynchburg and Durham, North Carolina, the Lennig station still stands, though it has been moved from its original location to the south edge of the town. Located in Halifax County, the station is now privately owned. The above image is from about 1920.

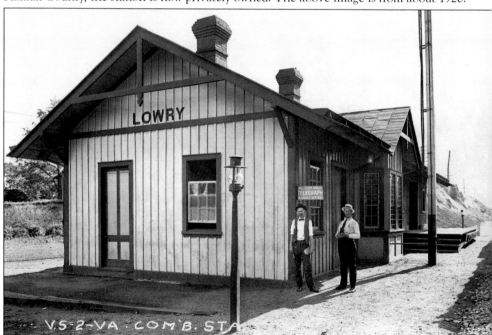

LOWRY. The Lowry combination station was located in the N&W Railway's Norfolk Division and is shown here in a 1920 photograph. The station still stands. Lowry is in Bedford County and is located east of Bedford between that town and Goode.

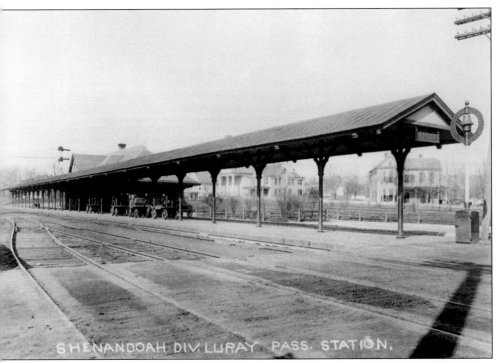

SHENANDOAH DIV. LURAY PASS. STATION.

LURAY. This station was built in 1906, and the image above is from about 1920. Luray is located in Page County and was in the railway's Shenandoah Division. Today the station has been restored and is owned by the municipality. Luray, the seat of Page County, is most noted for the presence of the nearby Luray Caverns.

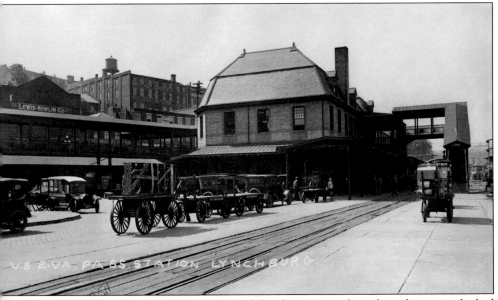

V. S. R. VA. PASS STATION LYNCHBURG

LYNCHBURG. Lynchburg's station still stands, and the above image shows how the station looked about 1920. Settled in 1757 by John Lynch, this city was being served by four railroads in the 1850s. Interestingly, it was the preferred site for the junction of the Shenandoah Valley Railroad and the N&W, but citizens complained about potential noise and other effects, so Roanoke was chosen.

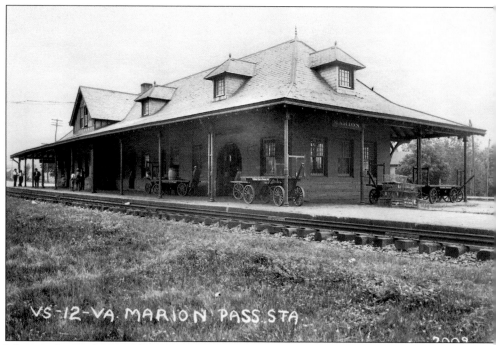

MARION. Located in Smyth County, Marion's station was built in 1904 as a combination station. The station still stands and is now used for commercial purposes. The above image dates from around 1920. Marion was named for American Revolutionary War officer Francis Marion and was also home of the noted American short story writer Sherwood Anderson.

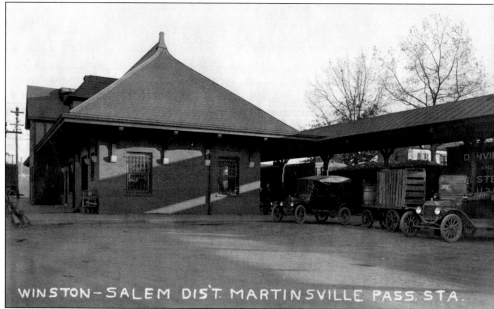

MARTINSVILLE. Located in the railway's Winston-Salem District, this photograph shows the station about 1920. Martinsville is an independent city and the seat of Henry County. It is home to the Martinsville Speedway, which is the shortest track in NASCAR. The town was founded by Revolutionary War general Joseph Martin.

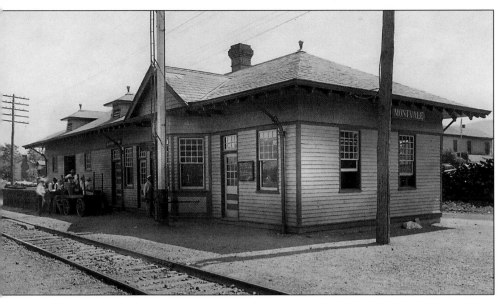

MONTVALE. The above photograph of the Montvale combination station dates from about 1920. Montvale is located in Bedford County. Bedford County was established in 1753 and was named in honor of John Russell, the fourth duke of Bedford, England, who had served as secretary of state for Great Britain.

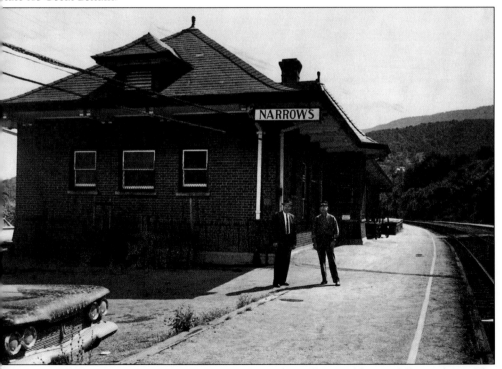

NARROWS. This station is located in Giles County and is still owned by Norfolk-Southern. The photograph of the station was taken in 1962. According to the 2000 census, the population of Narrows was 2,111. It is located in the scenic Jefferson National Forest and is between Pearisburg and the state line.

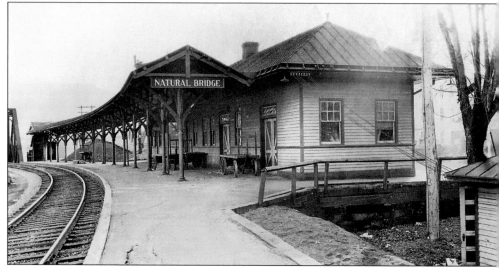

NATURAL BRIDGE. This image of the station at Natural Bridge dates from around 1920. Natural Bridge was a resort town in its prime with the Natural Bridge Hotel, which is in close proximity to Natural Bridge, a natural rock formation in Rockbridge County. This was surveyed by a young George Washington, whose initials are still carved upon the rock's face.

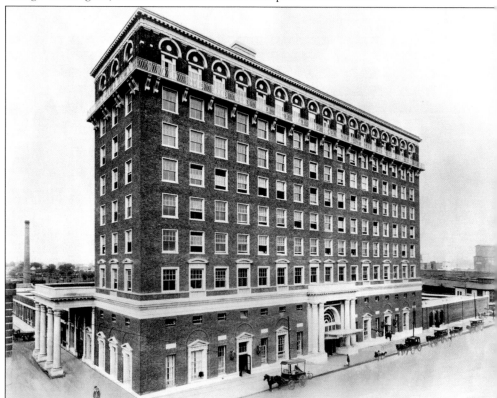

NORFOLK. This 1932 photograph shows the "new" Norfolk passenger station. This was a union station used by three separate railroads that were serving the Norfolk region at that time. The previous N&W station (see next photograph) burned.

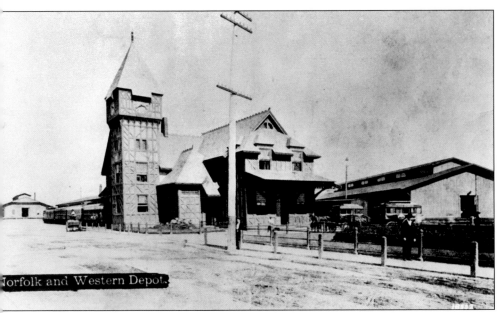

Norfolk and Western Depot.

NORFOLK. This *c.* 1900 image depicts the "old" Norfolk Passenger Station. This ornate passenger station burned on October 13, 1909. With this, the City of Norfolk was able to convince the three railroads present in the city (N&W, Virginian, and Norfolk Southern) to build a union station for use by all three lines, which was done.

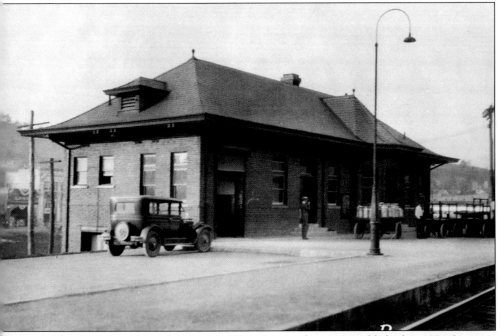

NORTON. Norton is an independent city in Wise County that was established in 1894. It was so named in honor of Eckstein Norton, president of the Louisville and Nashville Railroad. In 1889, the N&W dispatched five men to lay out the town, and the railroad arrived in 1891. This image dates from about 1920. Norton was served by the Clinch Valley District Trains Nos. 5 and 6. Those trains made their final passenger run in April 1959.

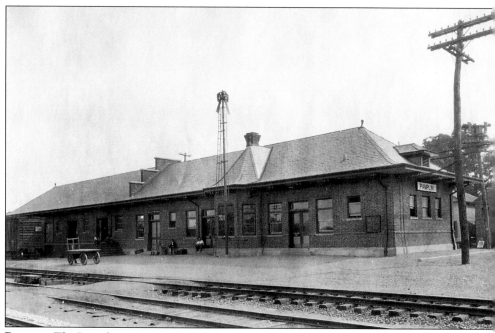

PAMPLIN. The Pamplin station still stands and functions for municipal purposes. Today the station houses a branch of the county library system and community meeting rooms. The depot is also home to the town's various holiday and civic festivities. The above image dates from around 1920. Pamplin straddles Appomattox and Prince Edward Counties.

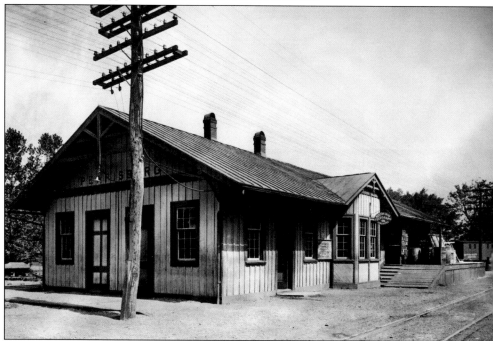

PEARISBURG. Pearisburg is the seat of Giles County. This image of the station is from 1920. Near Pearisburg, the railway had a small branch line that moved south with three stops—Suiter, Bastian and Rocky Gap. All of these were very small communities.

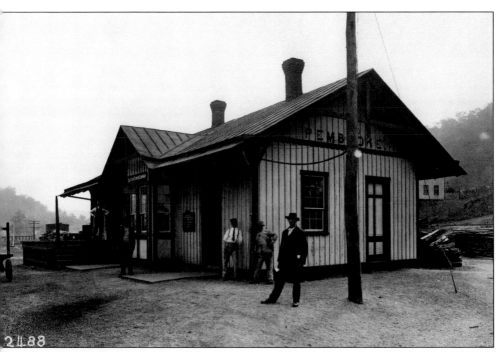

PEMBROKE. Pembroke is located in Giles County, and this photograph is dated about 1920. As with most small, rural communities, the railway ceased stopping at the station in the mid-1950s because of a lack of both passengers and freight. Pembroke's station no longer exists.

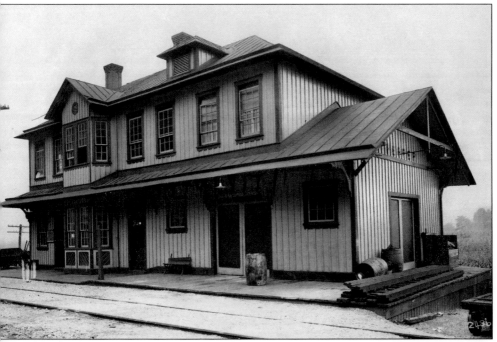

PEPPER. Pepper is located in Pulaski County, southeast of the Belspring area. The Pepper community was also along a line of the Virginian Railway. The image of the town's depot dates to about 1920.

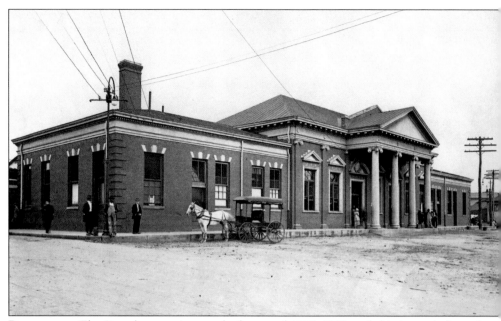

PETERSBURG. The Petersburg station was built around 1909–1910, and this image is from about 1920. The station still remains and is used today as a community center. Petersburg was a major rail center in the 19th century, especially with the completion of the Norfolk and Petersburg Railroad in 1858. This station was highly used during World War I when the N&W laid track connecting it to the army's Camp Lee.

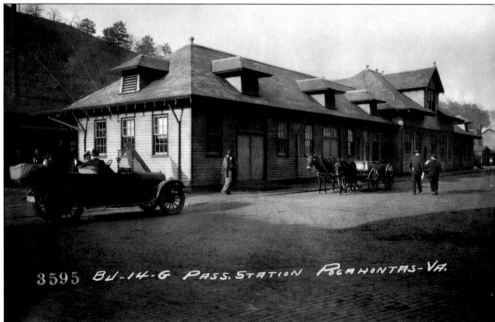

POCAHONTAS. Located in Tazewell County, this town has a long association with the rich coal reserves of the region, and those reserves helped launch the N&W economic prosperity beginning in the 1880s. The town is home to the Pocahontas Exhibition Mine and Museum. The above image dates to about 1920.

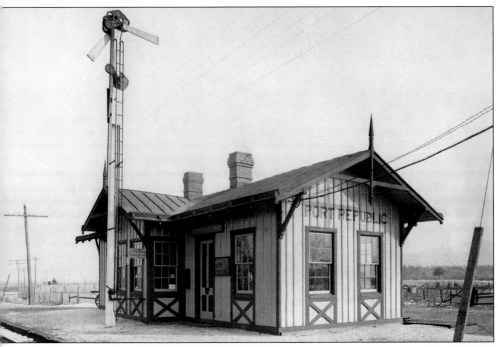

PORT REPUBLIC. Port Republic is located in Rockingham County and was part of the N&W's Shenandoah Division. The above image of the town's station is from 1920. Port Republic is probably best known for a Civil War battle that was fought there on June 9, 1862, as part of Jackson's Valley Campaign.

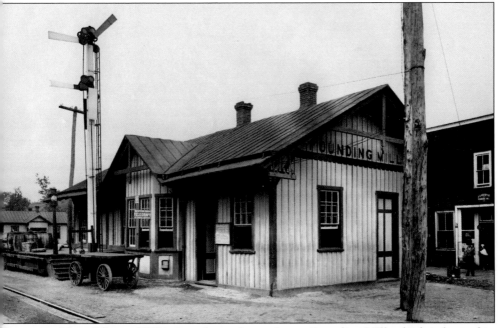

POUNDING MILL. This c. 1920 image shows the station at Pounding Mill, which is located in Tazewell County. Part of the Clinch Valley line, the N&W's rail lines were constructed through Tazewell County in the summer of 1888 and early winter of 1889.

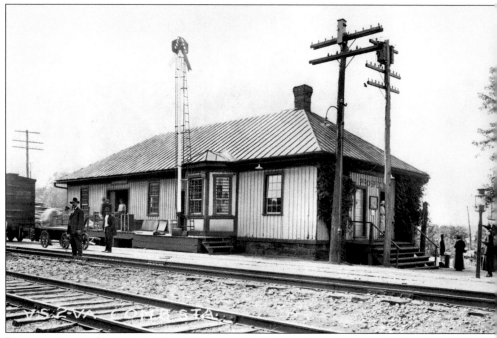

PROSPECT. Located in Prince Edward County, this combination station was in the railway's Norfolk Division. The Pamplin station, shown here about 1920, suffered a serious fire after it had been relinquished by the railway. The station was in a state of abandonment in 2007.

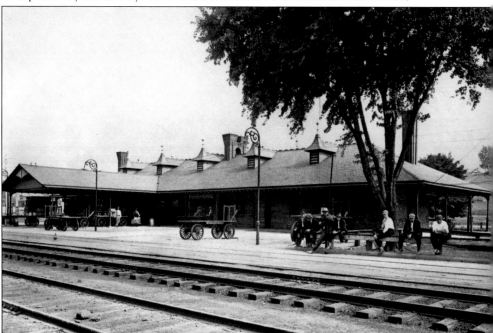

PULASKI. This *c.* 1920 image shows the Pulaski station in Pulaski County. After it was donated by the railway, the station was refurbished and reopened as a museum and offices for the local chamber of commerce. Unfortunately, the station was gutted by fire on November 17, 2008. It was listed on the National Register of Historic Places.

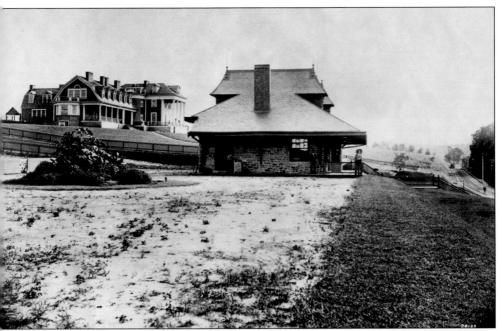

RADFORD. This historic photograph shows the Radford Inn and station in 1895. Radford, located in Montgomery County, is home to Radford University. The Virginia and Tennessee Railroad came to Radford in 1854 when it was known as "Central City." In 1921, the N&W established a Timber Preservation Plant there. Passenger service to Radford was eliminated in 1971.

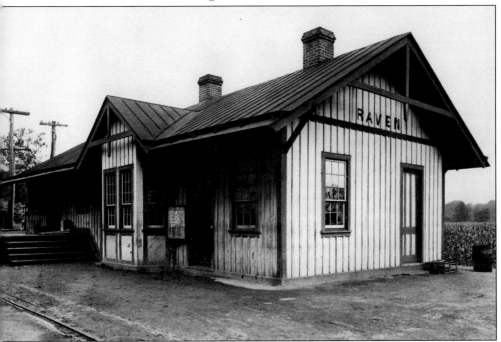

RAVEN. This image is from 1917. Raven is a region in Tazewell and Russell Counties. Raven was part of the N&W's Clinch Valley line. The N&W's line came through Raven in the early part of 1889, having been delayed by bad weather.

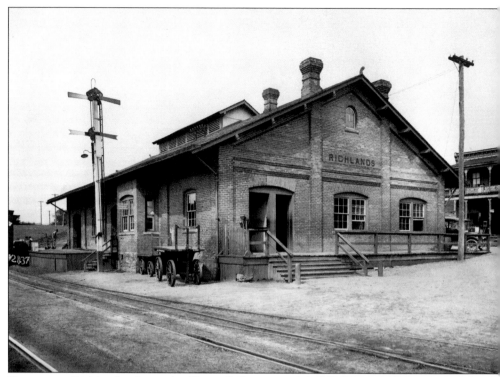

RICHLANDS. Richlands is located in Tazewell County, and the N&W arrived here in 1889. The old depot, since razed, stood across from the former Eagle and Dixie Hotels. The above photograph dates from about 1920.

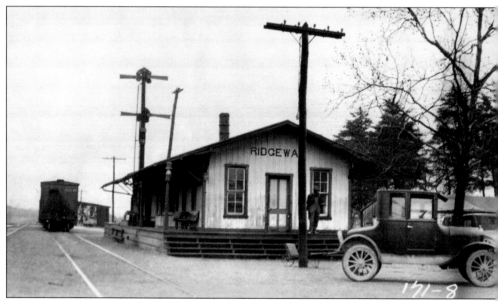

RIDGEWAY. This image shows the station around 1920. The structure still stands and is used for a private business. Ridgeway is located in Henry County. Henry County was originally named Patrick Henry County in honor of the state's first governor and an occasional resident of the area where some family members had settled.

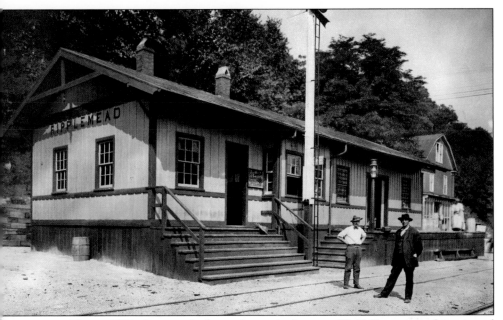

RIPPLEMEAD. This *c.* 1920 photograph shows the station's agent, W. T. Duncan, in his suit and an unidentified man. Ripplemead is located in Giles County. For southwestern Virginia, the presence of the N&W became critical to its economic well-being, both for agriculture and coal. Small stations such as this one are but one indication of what the railroad's presence could mean to a place that might otherwise not even have been named.

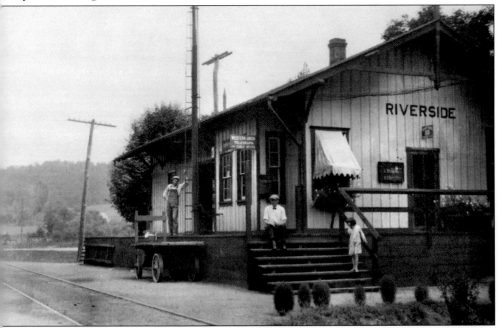

RIVERSIDE. This station was located between Buena Vista and Midvale in the N&W's Shenandoah Division along the Shenandoah River. The above image dates from 1928. The Shenandoah Division began as the Shenandoah Valley Railroad, which extended south from Hagerstown, Maryland, to Roanoke.

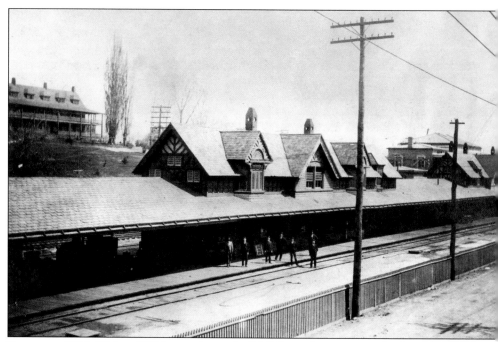

ROANOKE, 1890. This *c.* 1920 image shows the "old" Roanoke station in the foreground with the "new" station in the background. Hotel Roanoke, owned and operated by the N&W Railway for 100 years, is in the left background.

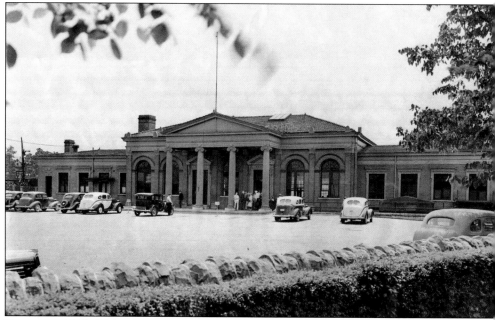

ROANOKE, 1905. This passenger station was built around 1904–1905 and is shown here in the early 1930s. The passenger station pictured here is located between the N&W's former shops and the Hotel Roanoke, and it was a prominent and busy passenger station during the N&W's peak service during World War II. Roanoke continues to hope for the return of passenger rail service to its city.

ROANOKE, 1949. This image shows the "new" passenger station in Roanoke with the Raymond Lowey redesign, which occurred between 1947 and 1949. The railroad wished to update the station with a more modern design. Today the structure houses the O. Winston Link Museum of rail photography and is on the National Register of Historic Places. This photograph is from 1958.

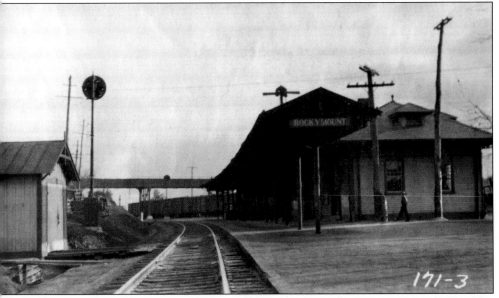

ROCKY MOUNT. The Rocky Mount station is still in use today as the visitors' center for Franklin County. This image dates to about 1920. Rocky Mount is the seat of Franklin County. Settled in 1760, the town was named after a steep cliff near the town.

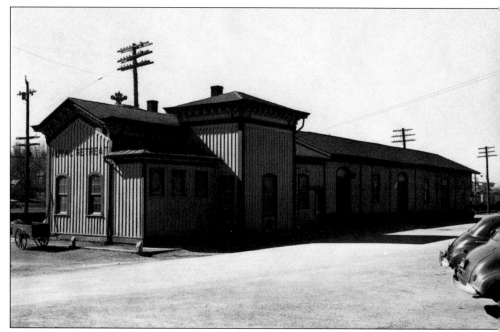

RURAL RETREAT. The Rural Retreat station was constructed in 1873 and is shown here as it looked in 1949. The former combination station still stands and is used for a private business. Rural Retreat is located in Wythe County.

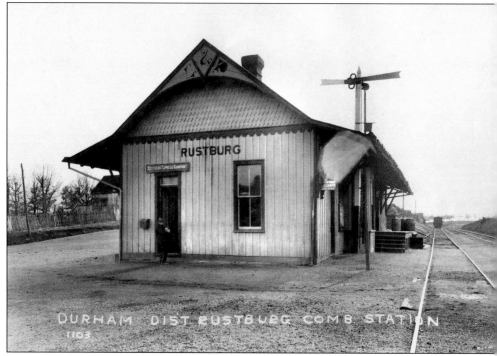

RUSTBURG. Located in Campbell County, Rustburg was in the railway's Durham District. This image of the combination station dates from about 1920. Rustburg was named for Jeremiah Rust who donated some 50 acres to establish the town in 1784. It is the county seat.

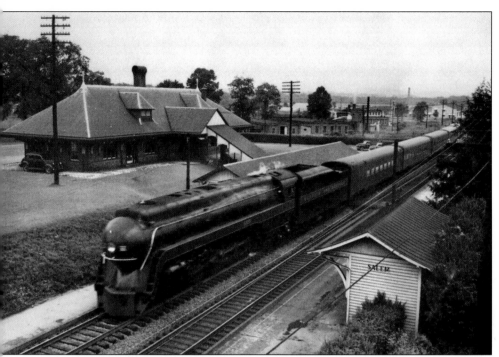

SALEM. This 1950 photograph shows Engine No. 25 at the Salem station. Built in 1891, the station still remains and is being used as a day care center for children. Salem is the county seat for Roanoke County and home to the Lutheran-affiliated Roanoke College.

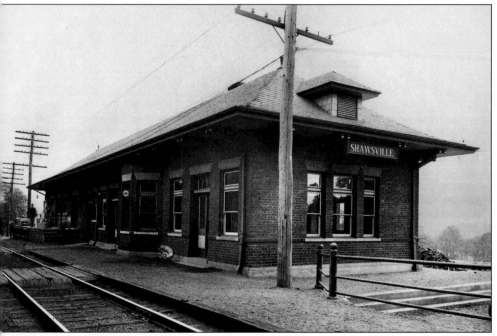

SHAWSVILLE. Shawsville is located in Montgomery County. This photograph is from 1920. Shawville is largely farmland today. At present, it has been identified as a potential site for a new rail facility to serve the Norfolk-Southern Corporation.

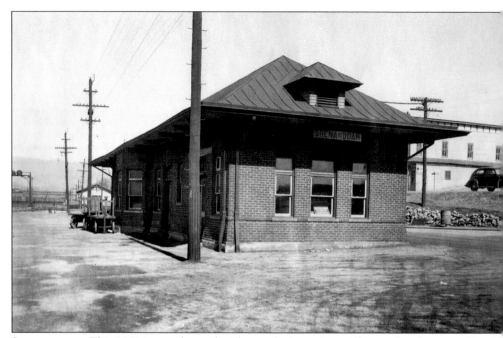

SHENANDOAH. This 1941 image shows the Shenandoah station, still owned and operated by the railroad as a yard office. Built in 1916, the station and community are located in Page County. For years, the N&W had a significant maintenance facility here, which was closed in 1957. The town was founded in 1837.

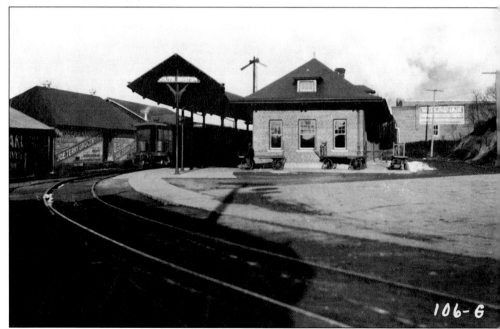

SOUTH BOSTON. This c. 1920 image shows the South Boston station, which is located in Halifax County. The structure remains today and is owned by the railroad. South Boston was named for Boston, Massachusetts. The first railroad to come through the town was the Richmond and Danville Railroad in the 1850s. It was a large tobacco market for years.

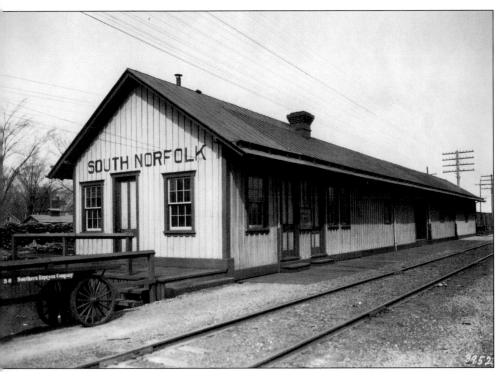

SOUTH NORFOLK. South Norfolk was an independent city in Norfolk County, having been chartered as such in 1919. It was among several communities that joined together to form the present-day city of Chesapeake. This image of the former town's station is from 1920.

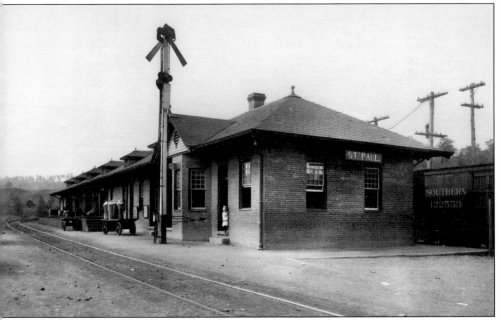

ST. PAUL. St. Paul is located in Russell and Wise Counties. The above photograph is from 1920. The station has since been demolished. St. Paul was so named because of the heavily Catholic immigrant population that came to the area to work on the railroad's construction.

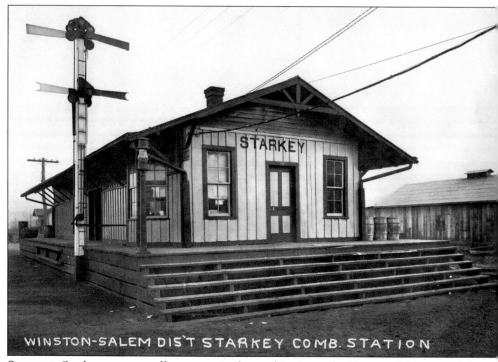

WINSTON-SALEM DIS'T STARKEY COMB. STATION

STARKEY. Starkey was a small community located in Roanoke County. This *c.* 1920 image shows the combination station that used to exist there, serving a line of the railway's Winston-Salem District.

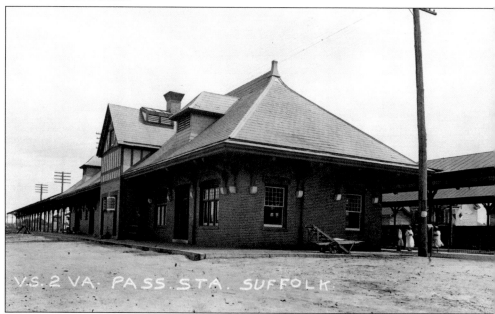

V.S. 2 VA. PASS. STA. SUFFOLK.

SUFFOLK. Located between Norfolk and Petersburg, this station was built in 1909. It was designed by architect Charles S. Churchill. The above image dates from about 1920. By the mid-19th century Suffolk was being served by both the Portsmouth and Roanoke Railroad and the Norfolk and Petersburg Railroad. Today it is the largest city geographically in the state.

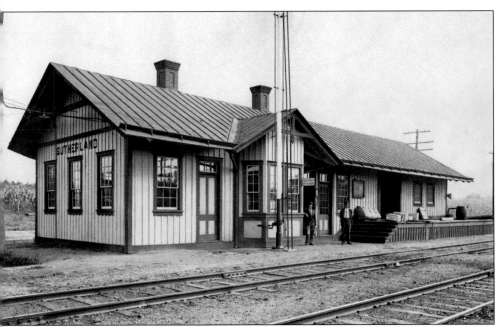

SUTHERLAND. Sutherland is in Dinwiddie County. This image of the station is from 1920. It was part of the N&W's Norfolk Division. Located west of Petersburg, Sutherland was besieged during the Civil War because of the presence of the Southside Railroad.

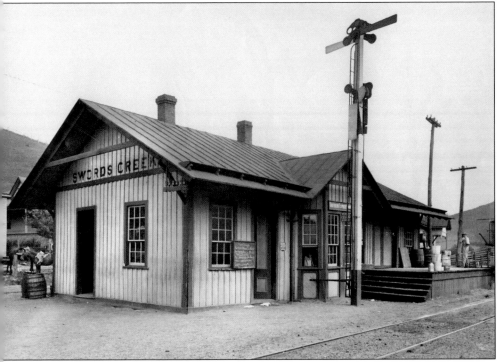

SWORDS CREEK. This station was located in Russell County. The image is from 1920. Swords Creek was part of the N&W's Clinch Valley line, which was constructed in the late 1880s as a means to connect the railroad with the coal reserves of far southwestern Virginia.

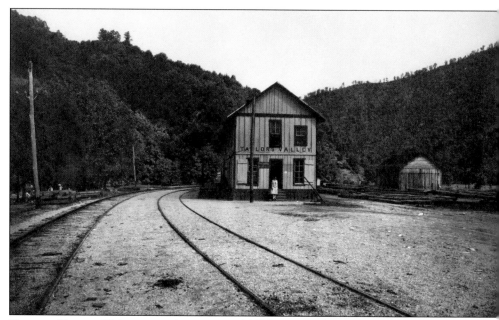

TAYLORS VALLEY. This station, shown around 1920, was on the N&W's Abingdon Branch. Rail came here in 1907 when the N&W completed a line from Damascus on what was originally supposed to be the Virginia-Carolina Railway to go from Abingdon, Virginia, to Todd, North Carolina. Today the rail bed is part of the Virginia Creeper Trail.

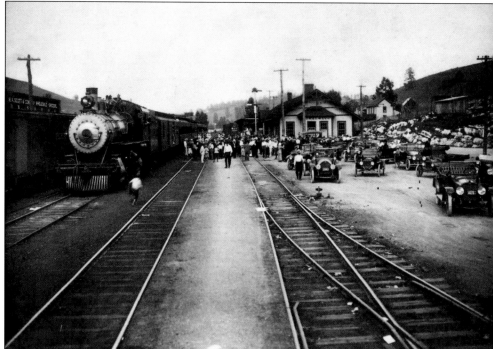

TAZEWELL. This 1920s image, which also graces the cover of the book, is of the Tazewell train station. What is prompting the activity depicted is not known. The station still remains. Originally called Jeffersonville, Tazewell is near the headwaters of the Clinch River.

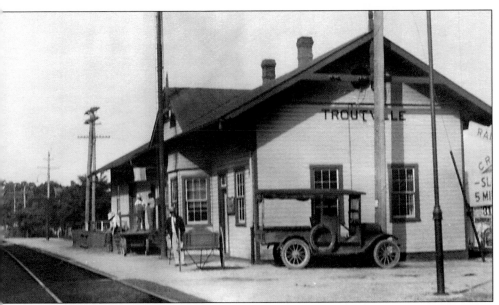

TROUTVILLE. Troutville is located in Botetourt County, and this image of its train station dates from the 1920s. When the Virginia and Tennessee Railroad came through this locale and built a station, there was no town, only three homes that belonged to three Trout brothers. Thus the place was called Troutville. By the 1890s, the town had grown significantly and was a shipping point for agricultural products.

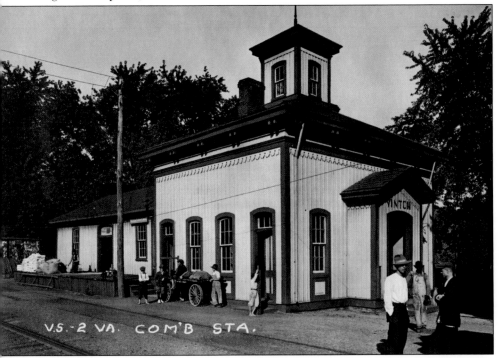

VINTON. Vinton is located in Roanoke County, and this image of its former combination station is from about 1920. Vinton was originally known as "Gish's Mill." Today Vinton is an incorporated town within the county, but the station shown in the above photograph no longer remains.

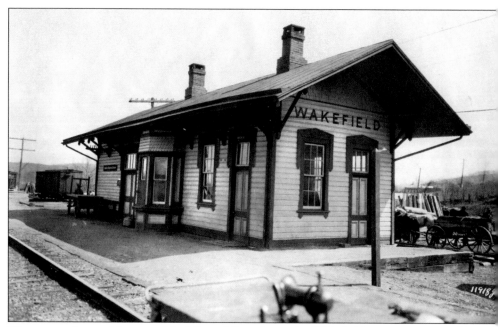

WAKEFIELD. Located between Norfolk and Petersburg, the Wakefield station is pictured here in the 1920s. Wakefield is located in Sussex County and was known as the "Peanut Capital of the World." Reportedly, the town was named by William Mahone's wife, Otelia, when she and her railroad executive husband traveled through the area naming stations. The name came from the novel *Ivanhoe*.

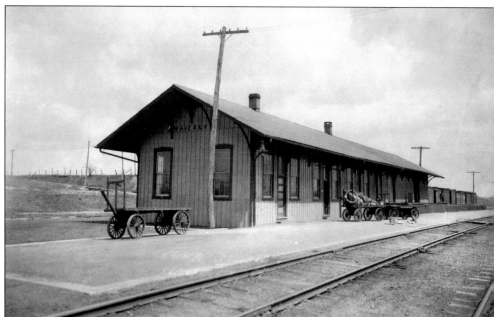

WAVERLY. Also located between Norfolk and Petersburg, Waverly is shown in this photograph from 1915. Situated in Sussex County, this town and station were also named by Otelia Mahone on that famous early train trip where she was allowed to name the railroad's stations. Like Wakefield, this was a name in the novel *Ivanhoe*, which she was reading at the time.

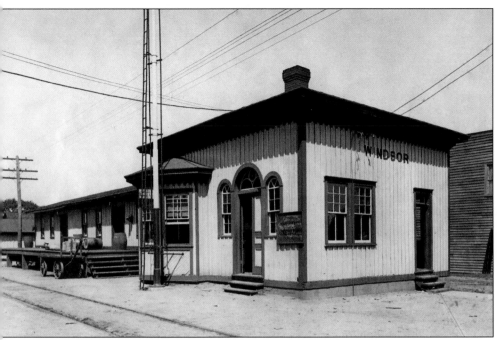

WINDSOR. Located in Isle of Wight County, the Windsor station was on the line between Norfolk and Petersburg. The station still remains, though it has been relocated. The above image is from 1917. This station and town were also named by Otelia Mahone from the novel she was reading when she came through the area.

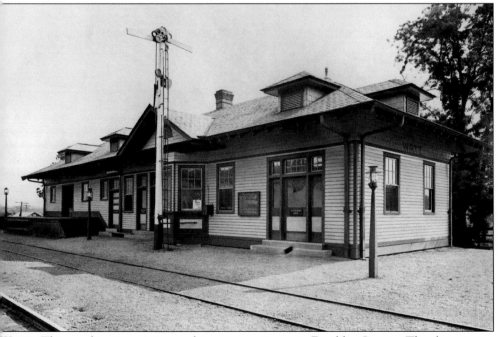

WIRTZ. This combination station and its community are in Franklin County. The above image is from around 1920. Wirtz was on the line that went south from Roanoke to Winston-Salem, North Carolina. Passenger service on this line was discontinued in the early 1960s.

WYTHEVILLE. Wytheville is located in Wythe County, and this photograph of its train station was taken in June 1948. The combination station still stands and is used as commercial property today. Wytheville is named for George Wythe, a signer of the Declaration of Independence.

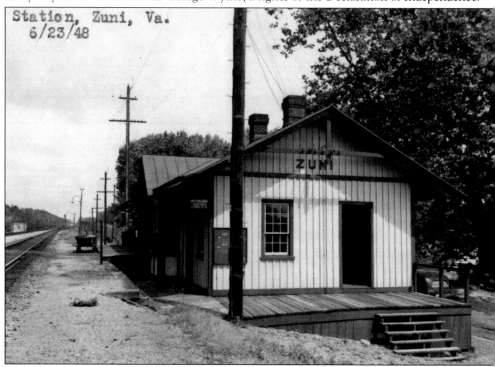

Station, Zuni, Va.
6/23/48

ZUNI. Zuni is a small community located in the Isle of Wight County. Its population hovers around 100 people, and much of the town was flooded and destroyed by the Blackwater River during Hurricane Floyd in 1999. This image of its train station was taken in June 1948. Zuni was served by Norfolk-Roanoke Accommodation Trains Nos. 7 and 8. These trains made their final run in 1957.

Three

OHIO

To understand the presence of the Norfolk and Western Railway in Ohio, one would have to go back, in part, to the development of the Scioto Valley Railway, which was incorporated on February 23, 1875, with Columbus and Portsmouth as its termini. On February 1, 1890, this railway was acquired by the Scioto Valley and New England Railway Company under a receivership arrangement. At this same time, the N&W was still building its Ohio extension, though the two railways did not connect physically.

The Ohio extension became critical to the N&W, as noted by N&W historian Pat Striplin: "Perhaps the most long-term result of the Ohio Extension was that it changed the N&W from a Southern road tied to agriculture to a Midwestern line relying mainly on coal."

Later, in 1890, the Norfolk and Western acquired the Scioto Valley and New England Railway Company (SV&NE). This acquisition required the N&W to build a bridge over the Ohio River. This five-span structure was described at the time as being a total of 1,737 feet long and was to be 40 feet above high water and 100 feet above low water. The inclusion of this railroad into the N&W system was reported by N&W president Frederick Kimball in 1890 as follows: "This property, now operated as the Scioto Valley Division, is in an unusually good physical condition, and has already proved to be a most valuable acquisition." The SV&NE, when acquired, extended from Ironton to Columbus, Ohio, and had 128.6 miles of track and 28.7 miles of sidings. To round out its line and connect with the heavy rail traffic in and around Cincinnati, the N&W acquired the Cincinnati, Portsmouth, and Virginia Railroad (CP&V) for $2.5 million in 1901. That particular railroad had many previous incarnations, being known first as the Cincinnati, Batavia, and Williamsburg, then the Cincinnati and Eastern, and then the Ohio and Northwestern before becoming the CP&V in 1890.

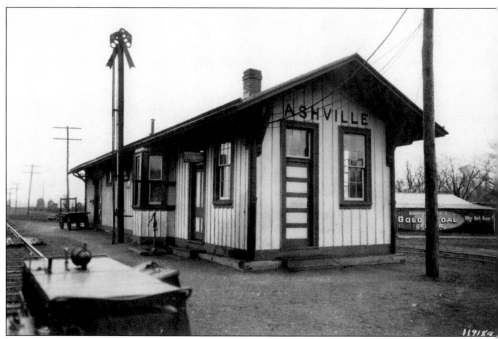

ASHVILLE. Originally part of the Scioto Valley Railway, this station was built in 1875. Located in Pickaway County, Ashville's station still remains at the corner of Madison and Cromley Streets, and is in use as a museum highlighting the history of the Scioto Valley Railway. The station has been listed on the National Register of Historic Places. The above photograph is from about 1920.

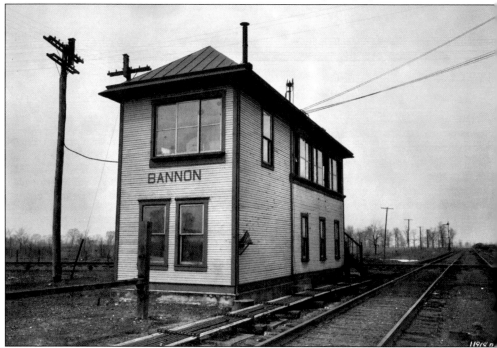

BANNON. Located in Franklin County, this station also served the Toledo and Ohio Central Railroad. This photograph is from around 1920. The station was razed in the 1930s.

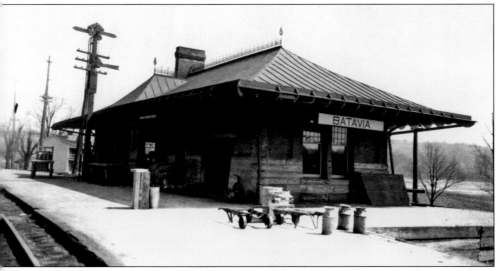

BATAVIA. Originally on the line of the forerunner of the Cincinnati, Portsmouth, and Virginia Railway, the station sat just off Main Street in Batavia, which is located in Clermont County. The station has since been razed. The above image dates from about 1920. Batavia derived its name from Batavia, New York, from where its early settlers came.

CHILLICOTHE. Built in 1910, this station still remains on East Second Street in Chillicothe, which is in Ross County. The image above is from 1925. Chillicothe was the first and third capital of the state of Ohio. Located along the Scioto River, the name comes from a Shawnee term meaning "principal town."

CINCINNATI, N&W STATION. In 1901, the Norfolk and Western acquired one of the last small railroads needed to round out its line for its Ohio operations—the Cincinnati, Portsmouth, and Virginia Railroad. This acquisition added 108 miles to the N&W's system and gained the railway entrance into Cincinnati. This image is of the N&W's freight station there in 1925.

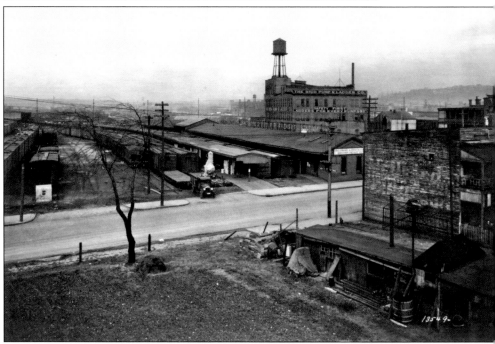

CINCINNATI, BRIGHTON. Labeled as the Cincinnati Union Terminal, this is the Brighton Freight Station. The image is from 1929. For years, the city of Cincinnati was served by multiple railroads, each having separate facilities and stations.

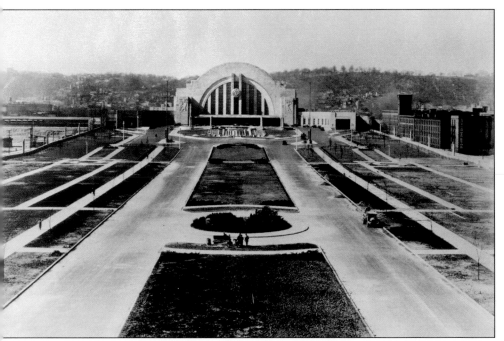

Cincinnati. This is the Cincinnati Union Terminal as it looked in April 1933. Today this facility is the Cincinnati Museum Center at Union Terminal, housing museums, theaters, and a library. At one time, there were no fewer than five different rail stations in Cincinnati, leaving passengers to navigate local transit if they needed to switch trains. In the late 1920s, plans came together to build a union terminal. This terminal was designed by principal architects Alfred Falheimer and Steward Wagner.

Circleville. This station was originally part of the Scioto Valley Railway and is still in use for a rail purpose today. The station is located on South Court Street in Circleville, which is situated in Pickaway County. The above image is from 1925. Circleville was founded in 1810 and was platted in a circular formation. Rail came through the town in 1876.

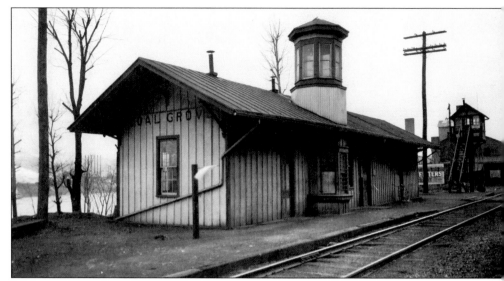

COAL GROVE. The 1925 image above shows the station located along Route 52 in Lawrence County. The Coal Grove community is situated along the Ohio River across the river from Ashland, Kentucky. In 1880, rail was extended to Coal Grove, making it for a short time the terminus of the Scioto Valley Railway, allowing it to connect with the Chesapeake and Ohio Railroad (C&O) via a car ferry.

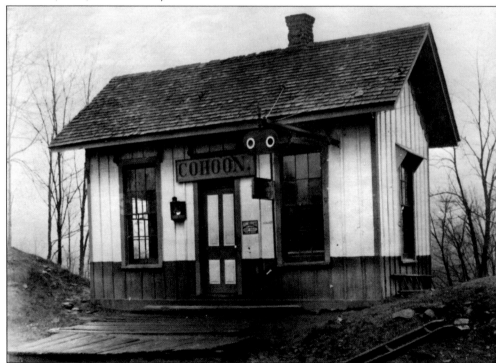

COHOON (PERINTOWN). Cohoon was located in Clermont County. The photograph of this station is from 1895. The station has since been razed, but the foreman's house (background of the photograph) is still standing. Originally known as "Perin's Mill," having been founded by Samuel Perin in 1813, Perintown is located on the East Fork of the Little Miami River.

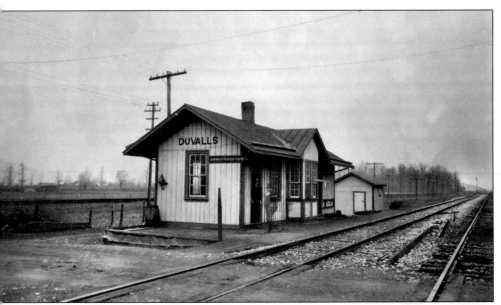

DUVALLS. This image from 1925 shows the station at Duvalls in Pickaway County. The station has been razed. Pickaway County's name was derived from the Pekowi and Shawnee Indians who inhabited the area.

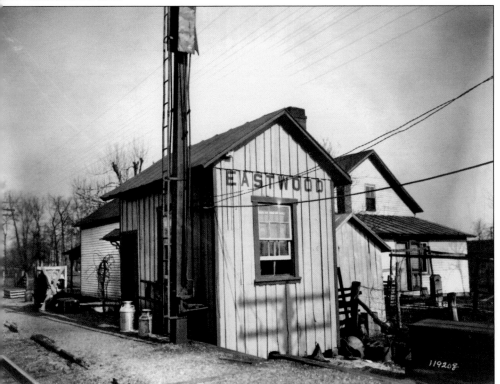

EASTWOOD. Eastwood is located in Brown County, and the above image of its station dates from about 1925. The station has been razed. Brown County was named for Maj. Gen. Jacob Brown, an officer in the War of 1812.

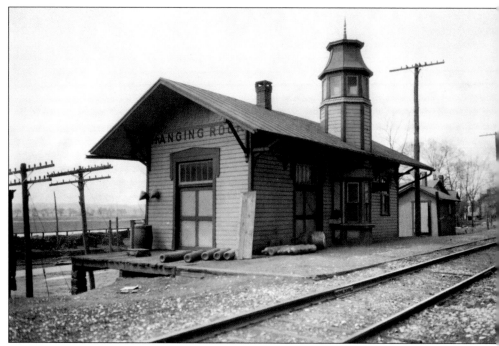

HANGING ROCK. This station's location was just off Main Street near the Hanging Rock Iron Company's furnace in Lawrence County. The above image dates from around 1925. According to the 2000 census, the population of Hanging Rock was 279.

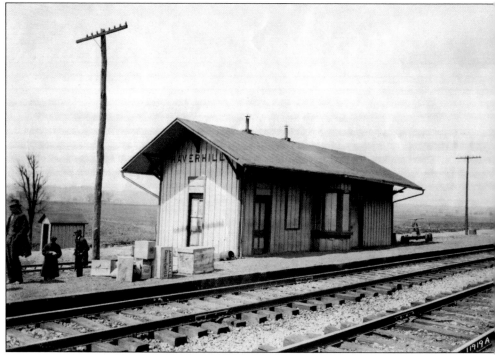

HAVERHILL. This c. 1925 image shows the station at Haverhill in Scioto County. The station has been razed. Today Haverhill is part of the Green Township, located along the Ohio River.

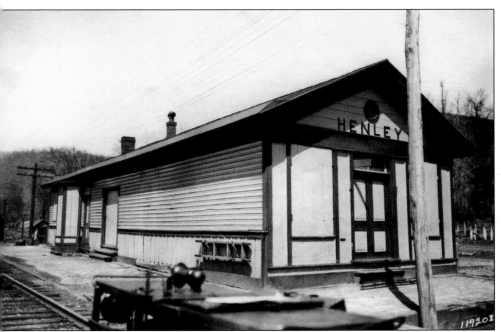

HENLEY. Taken in Scioto County, this image dates from 1925. The station has been razed. This station was originally served by the Scioto Valley Railway, later acquired by the N&W.

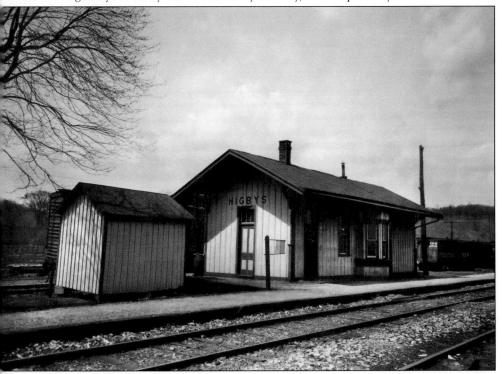

HIGBYS. This photograph shows the station as it looked in 1925. The community is located in Ross County. The station was razed on October 1, 1936. Ross County was named for U.S. senator James Ross of Pennsylvania.

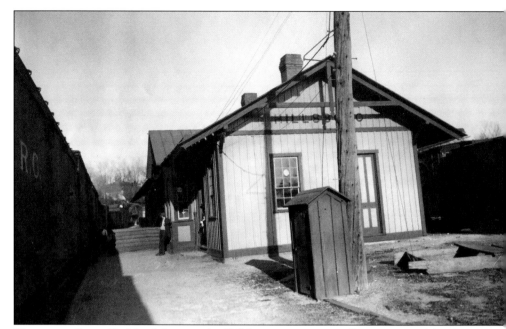

HILLSBORO. Set in Highland County, the Hillsboro station originally was a part of the Cincinnati, Portsmouth, and Virginia Railway system. The station was razed. The above image dates to around 1925.

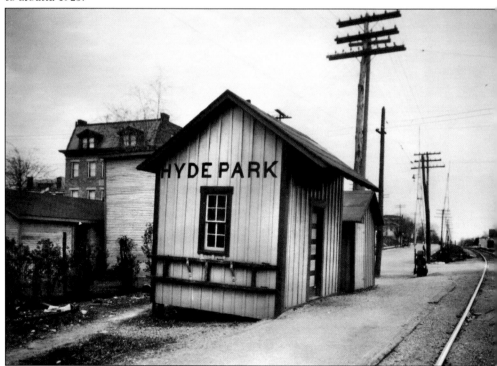

HYDE PARK. The above image is from 1925. The station, located in Hamilton County, has been razed. Hyde Park is today a neighborhood within present-day Cincinnati. Its name comes from Hyde Park in New York City and was meant to suggest a neighborhood for wealthy residents.

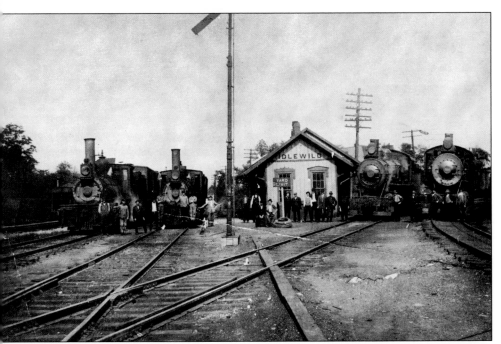

DLEWILD. Located in Norwood, Hamilton County, this was part of the Cincinnati, Portsmouth, nd Virginia Railway system. The above image is from 1903. The station has been razed. Norwood s an enclave within present-day Cincinnati, having been established originally as a wooded uburb north of the city.

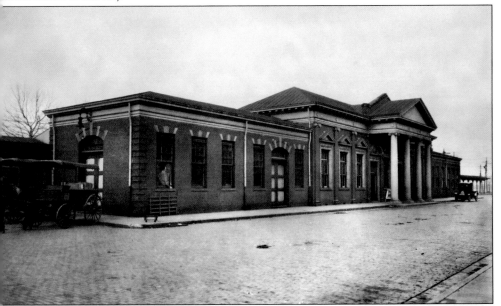

RONTON. Located in Lawrence County, the Ironton station still stands at the corner of Bobby Bare Boulevard and Park Avenue as a commercial building. Built in 1907, the station is listed on he National Register of Historic Places. The above image dates from around 1925. The town vas named for the area's rich iron-ore content. In 1890, the town was a terminus of the Scioto Valley and New England Railway.

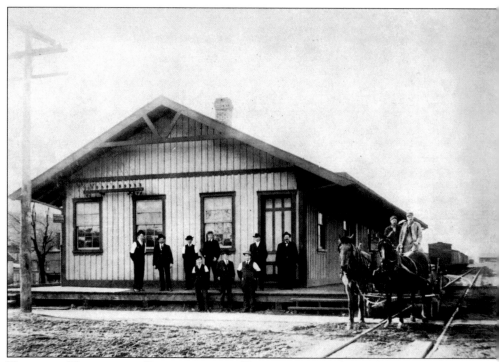

KINGSTON. The station at Kingston, a part of Ross County, was located on Railroad Street just north of Third Street. It has been razed. This image was taken around 1925.

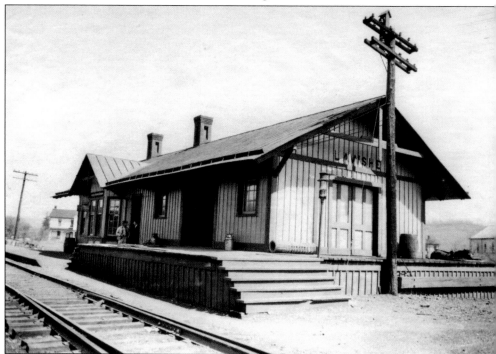

LAWSHE. This 1925 image shows the station at Lawshe in Adams County. The station has been razed. Adams County was named in honor of Pres. John Adams.

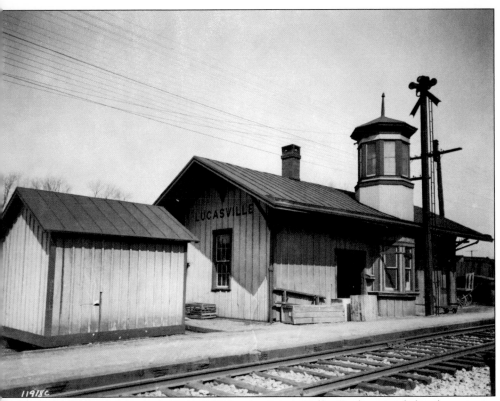

LUCASVILLE. This station was built in 1877 by the Scioto Valley Railway, and the above image dates to around 1925. The station was remodeled in 1926, closed on September 13, 1968, and razed on March 12, 1969. It was located on East Street in Lucasville, which is in Scioto County.

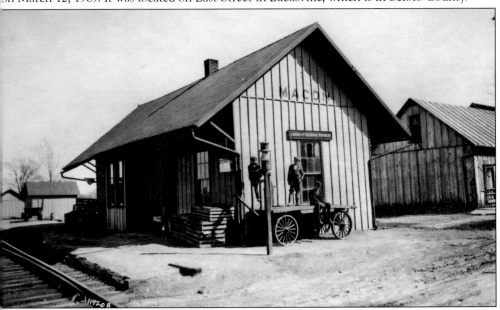

MACON. This station, shown here around 1925, was located in Brown County and was razed. This station was in the Hillsboro district of the Scioto Division.

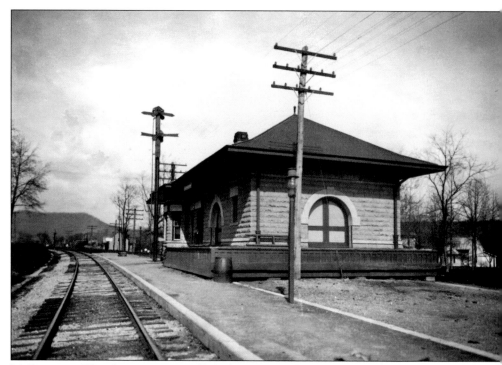

MCDERMOTT. This depot was originally built in 1876 and was used by the Cincinnati and Eastern. It was taken over and rebuilt by the Norfolk and Western in 1905, was closed on May 10, 1968, and was razed in 1969. It was located on Barber Street in McDermott, which is in Scioto County. The above image dates to around 1925.

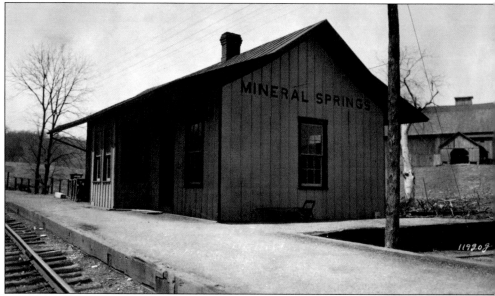

MINERAL SPRINGS. Located in Adams County, the station at Mineral Springs was originally part of the Cincinnati, Portsmouth, and Virginia Railway system. It was the last station before the Scioto County line near Bush Creek State Forest. This image was taken around 1925. The station has been razed.

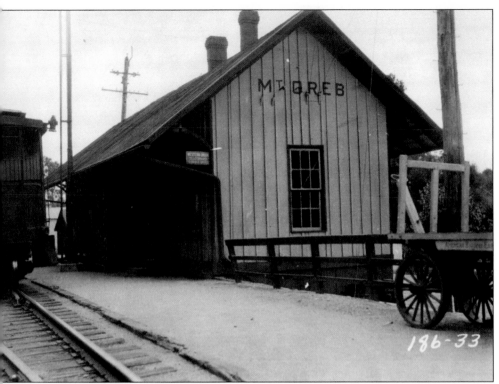

MOUNT OREB. Located in Brown County, this station still stands at North High and Front Streets. It is used for private commercial purposes. The station is also listed on the National Register of Historic Places. The above photograph dates from around 1925.

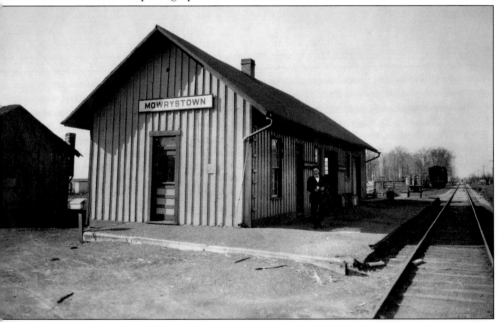

MOWRYSTOWN. The above image is from the mid-1920s and shows the Mowrystown station, which was located in Highland County. The station was razed.

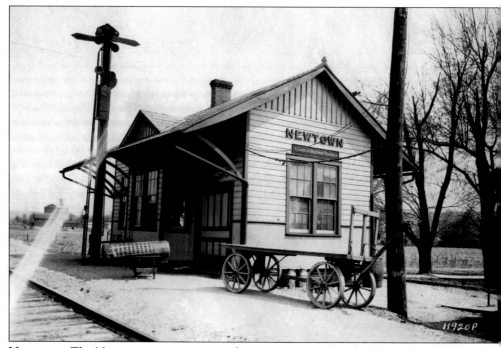

NEWTOWN. The Newtown station was razed many years ago, but this image shows that station during the 1920s. Newtown is located in Hamilton County. Newtown was so named when it was incorporated in 1901. Prior to that, the town had been called Mercersburg.

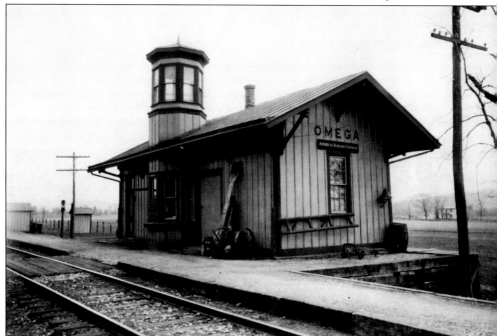

OMEGA. Built in 1878, the station at Omega was originally on the line of the Scioto Valley Railway. This image is from 1918. The station was razed in 1948. The town of Omega was previously known as Sharonville.

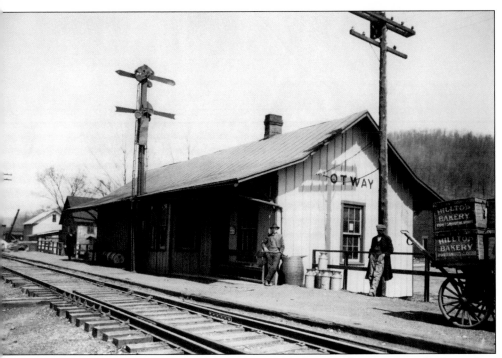

OTWAY. The station at Otway, shown here in a *c.* 1925 photograph, was originally located on Walnut Street in Otway and was then relocated a short distance. The station was razed in September 1999. Otway is located in Scioto County, and in the 2000 census, its population was 86. The town was platted in 1884.

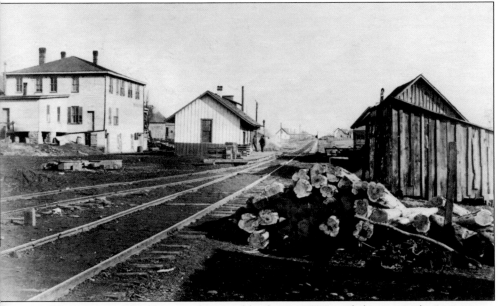

PEEBLES. The station at Peebles was destroyed by fire in 1906, and then a similar station was rebuilt. Peebles is located in Adams County. Peebles is most noted for being the home of the Great Serpent Mound, a 1,330-foot-long, 3-foot-high prehistoric effigy mound. The first railroad to go through Peebles was the Cincinnati and Eastern in 1881.

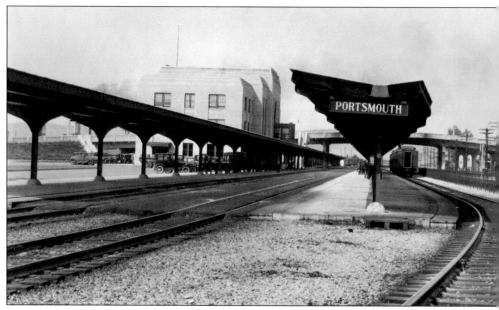

PORTSMOUTH, 1931 STATION. This November 1932 photograph is of the Portsmouth passenger station. It was built in 1931 and was razed in 2004, having been officially vacated by Norfolk Southern in 2003. The building was transferred to the Scioto County Commission, which had it demolished. On the site today is the county jail.

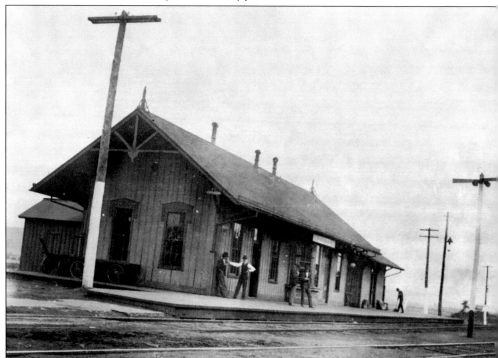

PORTSMOUTH, CP&V STATION. This June 1896 image is of the "old" Portsmouth station, which was originally constructed by the Cincinnati, Portsmouth, and Virginia Railway. Portsmouth is located in Scioto County.

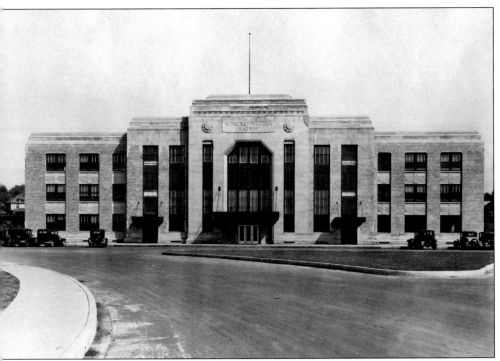

PORTSMOUTH, NEW STATION. This image is from November 1932. Today Portsmouth still has passenger rail service, being served by the Cardinal Line of Amtrak, but the passenger station is located across the Ohio River in South Shore, Kentucky.

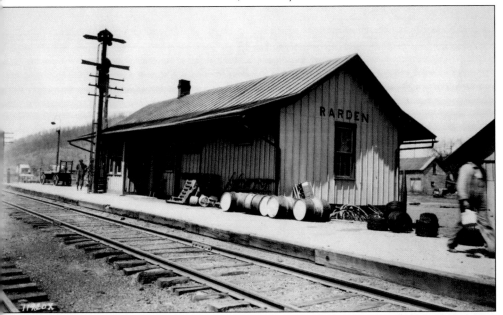

RARDEN. This image shows the Rarden station as it looked around 1925. The structure was located on Taylor Street in Rarden. Rarden is in Scioto County. In the 2000 census, the population of Rarden was 176. Settled in 1846, Rarden was originally called Moccasin by its early settlers from Pennsylvania.

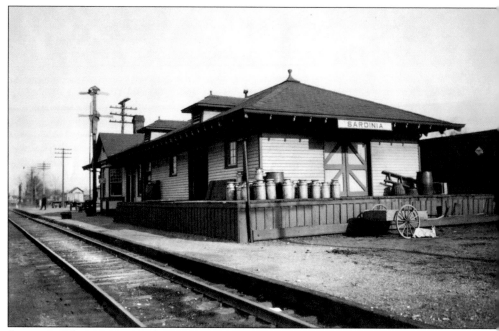

SARDINIA. This station was located in Brown County. The station has been razed. The image of the station at Sardinia was taken in 1925. The town's name comes from the Italian island of Sardinia.

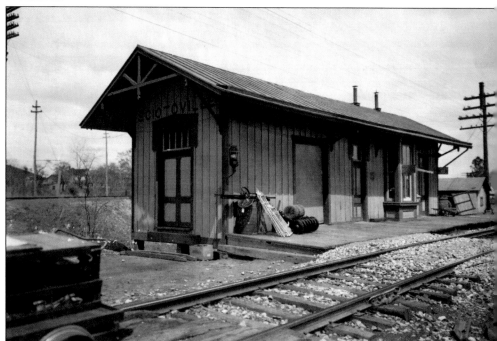

SCIOTOVILLE. This vintage photograph is dated 1919. The station at Sciotoville was located on Front Street. It was closed and subsequently razed in 1968 for a highway widening project. Sciotoville was platted by William Brown in 1841, but in 1921, the town was annexed into the city of Portsmouth.

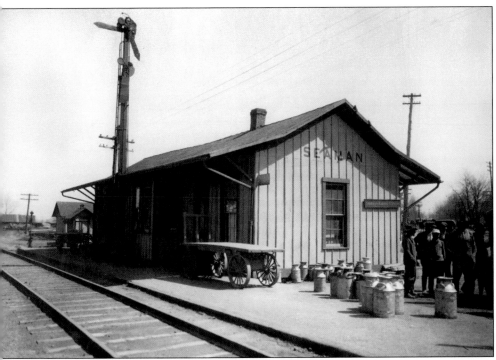

SEAMAN. This mid-1920s image shows the station at Seaman in Adams County. Seaman was almost the exact midpoint on the N&W's line between Portsmouth and Cincinnati.

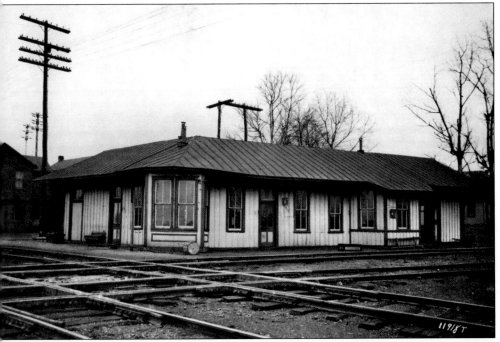

VALLEY CROSSING. The station at Valley Crossing was located in Franklin County and also served the Hocking Valley Railway. This image is from around 1920. The station was razed in the early 1960s.

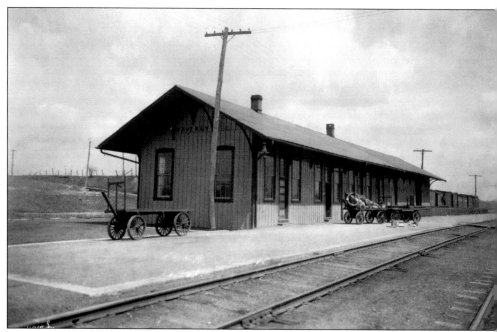

WAVERLY. This picture shows the Waverly station in 1920. The station was built by the Scioto Valley Railway in 1877 and was remodeled in 1913. The station closed in July 1976. Shortly thereafter, the structure was purchased by a local businessman and relocated in 1977. Unfortunately, the building was destroyed by an arsonist in 1979.

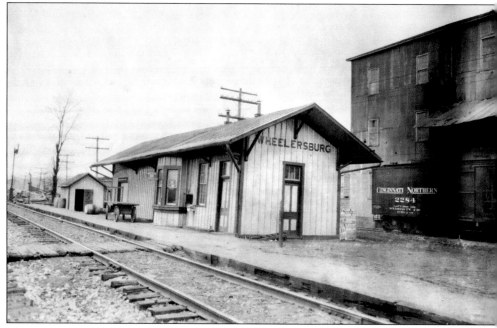

WHEELERSBURG. This image is from early 1920. The flour mill seen on the right caught fire on May 30, 1920, and the fire spread to the depot as well. A similar-sized station was then rebuilt in the same location. The station closed on September 16, 1968, and was razed later that same year. Wheelersburg is located in Scioto County.

Four

NORTH CAROLINA

The Norfolk and Western entered North Carolina at three different places. First, there was the Lynchburg-Durham line. The Lynchburg and Durham Railroad that connected the two large communities was completed on September 12, 1890, having begun three years earlier. Some three years later, the railroad was leased to the N&W, and then on September 24, 1896, it was purchased outright.

Developing a rail link between Lynchburg and Durham had been a difficult process, with three different rail companies trying the venture unsuccessfully in the 1880s. The line eventually was 117 miles. The N&W provided passenger service along this line from the time it acquired it until 1958.

The second venture into North Carolina by the N&W was a line from Roanoke, Virginia, to Salem, North Carolina. The Roanoke and Southern Railway had been organized in 1886, and work commenced, moving northward from Winston-Salem, in 1888. The line reached Martinsville in 1891, and the entire line was completed in 1892. As with the Lynchburg and Durham, the Roanoke and Southern was first leased by the N&W and then purchased in 1896, becoming part of the Shenandoah Division. It eventually had 123 miles of track and has often been referred to as the "Punkin' Vine" because of its twisting route. Passenger service was eventually scaled back along this line in the 1950s and eliminated entirely in 1963.

The final portion of a North Carolina presence in the N&W system comes from the "Virginia Creeper" line out of Abingdon and south to West Jefferson, North Carolina. In the early 1900s, the N&W became interested in extending the line into North Carolina, and by 1914, it had crossed White Top Mountain and was at Elkland, North Carolina, some 75 miles from Abingdon. Later the terminus would become West Jefferson. The N&W eventually abandoned the line in 1977 as a result of a lack of freight. Passenger service along the line had ended in 1962.

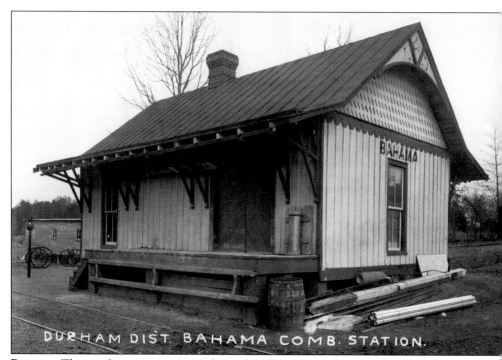

DURHAM DIST. BAHAMA COMB. STATION.

BAHAMA. This combination station was located in the Durham District, and the above photograph dates from about 1920. Bahama is an unincorporated town in Durham County. Settled around 1750, it was first known as Balltown. The name was later changed to "Bahama," a combination of the first two letters of names of three prominent families in the area—Ball, Harris, and Magnum.

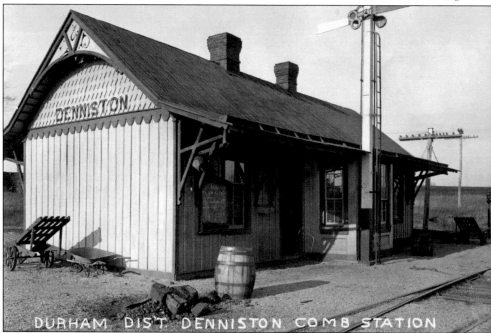

DURHAM DIST DENNISTON COMB STATION

DENNISTON. This combination station was in the Winston-Salem District, and the image is from about 1920. Passenger service on this line ended in the early 1960s.

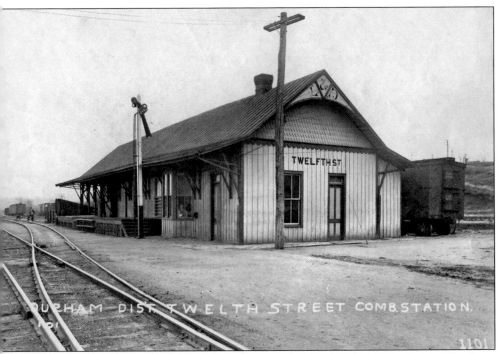

DURHAM. This *c.* 1920 image was identified as the Twelfth Street combination station in Durham. The seat of Durham County, Durham is home to Duke University. Durham was sited in 1853 to be the rail depot between Raleigh and Hillsborough. The railroad named the depot station for a local physician who had donated land for that purpose, Dr. Bartlett S. Durham.

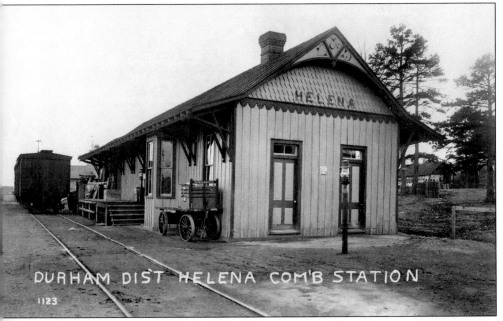

HELENA. This combination station was located in the Durham District, and the above photograph dates from around 1920. All passenger service on the Lynchburg-Durham line had ended by 1958.

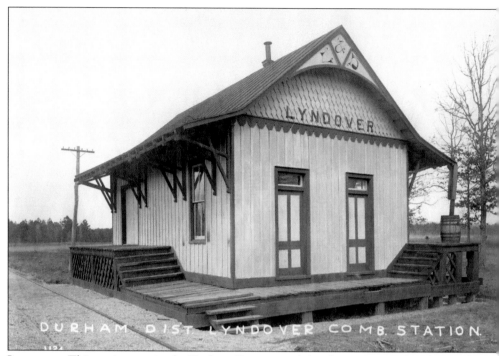

LYNDOVER. This station was in the Durham District, and the above image is dated around 1920. Located in tobacco country, Lyndover was on the N&W's Lynchburg-Durham line, which originally had been the Lynchburg and Durham Railroad before its acquisition by the N&W in 1896.

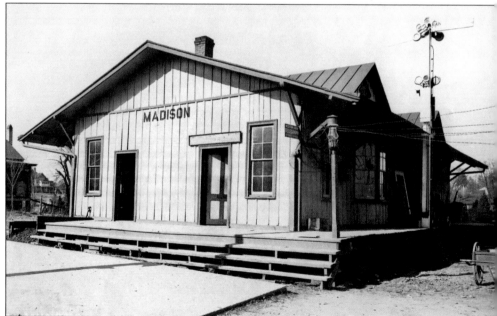

MADISON. This combination station was in the Winston-Salem District, and the above image shows the station as it looked around 1920. Madison is located in Rockingham County and was chartered in 1815 by the state legislature, who named the town after Pres. James Madison. Train travel began in Madison in 1888, and for many years, its economy was tobacco-based.

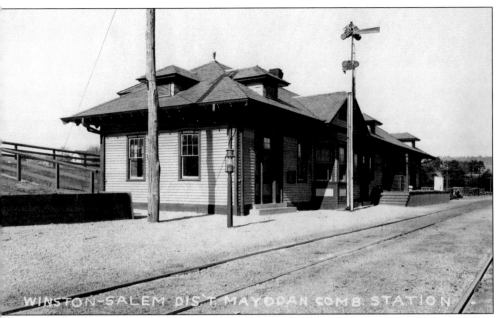

MAYODAN. This *c.* 1920 image shows the Mayodan combination station in the Winston-Salem District. Originally this was on the line of the Roanoke and Southern that ran from Salem, North Carolina, to Roanoke, Virginia, and was later acquired by the Norfolk and Western. Mayodan was incorporated as a town in 1899. It was named for the convergence of the Mayo and Dan Rivers.

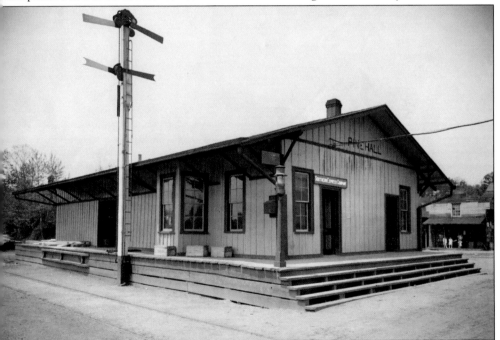

PINE HALL. This combination station was in the Winston-Salem District, and the above image dates from around 1920. In 2005, the station was reported as still standing but was in an abandoned state, overgrown with trees and shrubs. Pine Hall is an unincorporated town in Stokes County near Belews Lake.

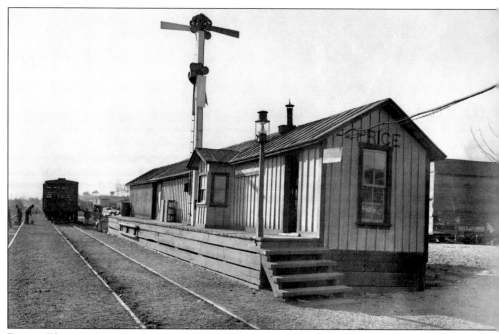

PRICE. This combination station was in the Winston-Salem District, and the above image i
from 1920. Price is an unincorporated town in Rockingham County. Passenger service on thi
line ended in the late 1950s.

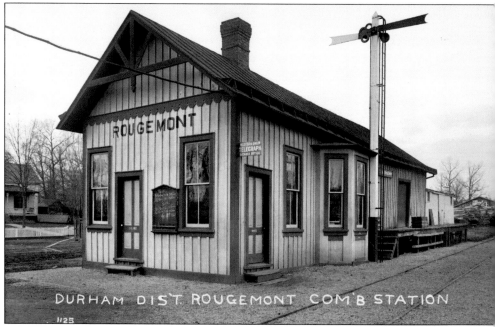

ROUGEMONT. This combination station was located in the Durham District, and the above
photograph was taken on March 1, 1917. In 2007, only the rear portion of the freight depot
remained, but restoration plans were underway to rebuild the station back to its original dimension
as seen in the photograph. Originally, the depot was on the Lynchburg and Danville rail line
which was later acquired by the N&W.

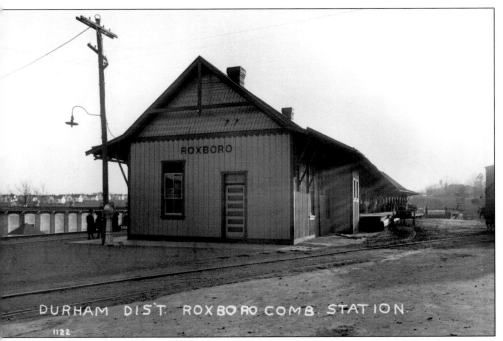

DURHAM DIST. ROXBORO COMB. STATION.

1122

ROXBORO. This combination station was located in the Durham District, and the above image was taken on March 1, 1917. The freight portion was moved and is currently being used as a storage facility. The passenger portion was razed. Originally, this station was on the Lynchburg and Durham rail line, which was later acquired by the N&W.

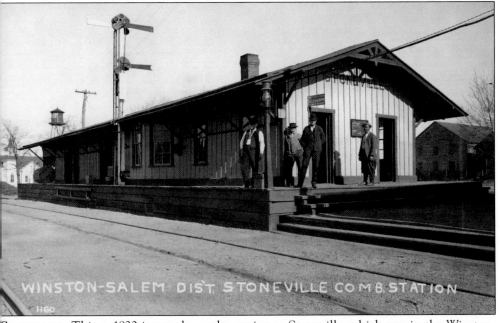

WINSTON-SALEM DIST. STONEVILLE COMB. STATION

1160

STONEVILLE. This c. 1920 image shows the station at Stoneville, which was in the Winston-Salem District. Located in Rockingham County, the town was originally known as Mayo. The small village developed around the general store owned by Thomas and Pinkney Stone, being incorporated and renamed in 1877. The Roanoke and Southern Railway arrived here in 1892.

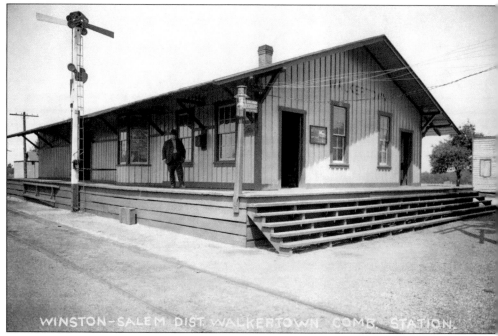

WALKERTOWN. This combination station was in the Winston-Salem District and was originall on the Roanoke and Southern rail line that was acquired by the N&W. The above image date from about 1920. The depot still stands today but is not in use. Walkertown was named fo Dr. Robert Walker and is located in Forsyth County.

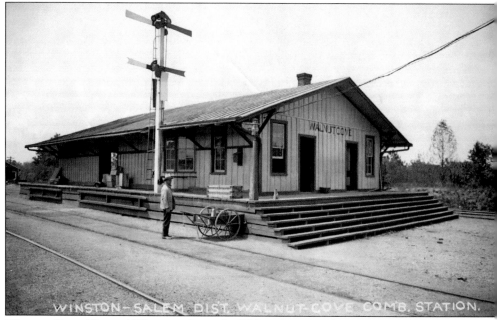

WALNUT COVE. This c. 1920 image shows the Walnut Cove combination station that was locate in the Winston-Salem District. Walnut Cove is in Stokes County and was chartered in 1889. It name was derived from the abundance of walnut trees in the area. Remnants of the old depo still remain along Depot Street in the town.

Five

PROMOTING THE RAILS

The Norfolk and Western Railway employed a cadre of people to promote its various rail enterprises—photographers, writers, and a public relations department. In addition to producing its corporate magazine beginning in the 1920s, the Norfolk and Western created advertisements that ran in major magazines and newspapers throughout its service region, as well as posters, brochures, ticket holders, calendars, and other assorted items. The following pages show a very small sample of the kinds of public relations pieces produced by the railway.

One note of interest is the stock photography used by the railway to illustrate new passenger cars or amenities, which employed the use of models posing as passengers. One sees them conversing in a lounge car, enjoying a cigarette in the smoking car, dining, or otherwise enjoying their comfortable seat aboard the *Pocahontas* or *Powhatan Arrow*. Almost always, these "models" were N&W employees asked to sit for the photograph. Fortunately, these vintage images, while staged, did provide a photographic record of the interiors of these passenger cars and their use that might not otherwise have been shown.

In addition to promoting passenger service, the N&W was also interested in promoting the reliability and efficiency of its freight operations. Perhaps not as romantic as a new luxury passenger coach, the notion of "Precision Transportation" and other such slogans helped distinguish the N&W as a major provider for the transportation of goods, including coal. During World War II, the advertisements often took on a patriotic tone in keeping with the national sentiment of the time, but it should be acknowledged that the N&W Railway, along with the nation's other railroads, was a critical function in supplying the nation's troops and ships during the period.

Whatever the cause, the image of the N&W often became long associated with its effective marketing program. The Native American maiden comes automatically to mind when one mentions the *Pocahontas* or the muscled warrior of the *Powhatan Arrow*. The goateed swashbuckler of the Cavalier is again visually synonymous with the train of the same name. The staying power of these and other images over the decades is testimony to the work of many within the N&W corporate family who promoted the rails.

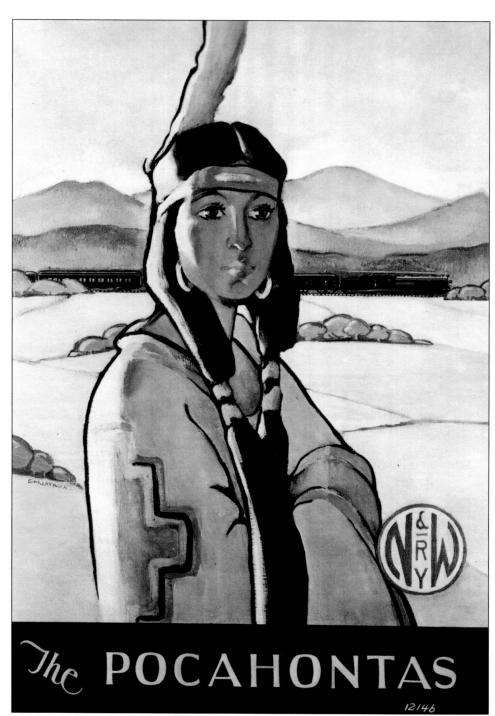

12146

ADVERTISEMENT FOR THE POCAHONTAS. The *Pocahontas* made its maiden run on November 21 1926, between Norfolk, Virginia, and Cincinnati and Columbus, Ohio. The name "Pocahontas" was the result of a contest sponsored by the N&W, and the winner was a Portsmouth ticket agent E. V. Perdew. The *Pocahontas* was the last wholly operated N&W passenger train left when Amtrak took over passenger service on May 1, 1971.

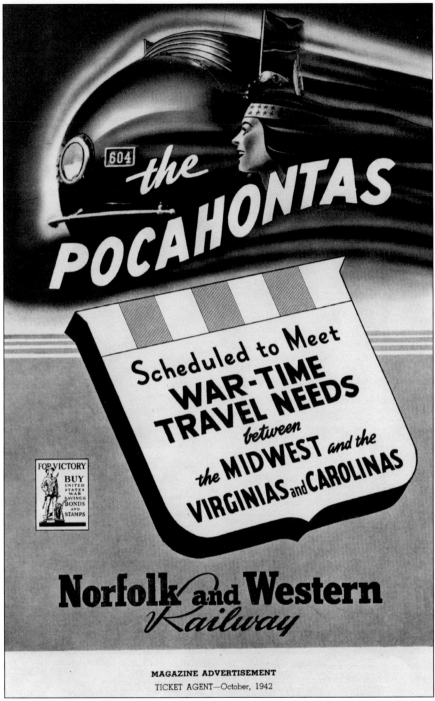

ADVERTISEMENT FOR THE POCAHONTAS. This advertisement is from August 1943 and clearly has a theme related to World War II. Passenger service spiked during this period for the N&W. The name "Pocahontas" may have appealed to the N&W because the train ran through the Pocahontas coal fields in Virginia and West Virginia that had been named for the Native American so prominent in Virginia's early history.

"The POCAHONTAS"
"The CAVALIER"

Cool
AS AN OCEAN BREEZE

AIR-CONDITIONED

PULLMAN CARS
DINING CARS
LOUNGE CARS

Air-Conditioned Coaches

will be in service within the near future

Clean
AS RAIN-WASHED AIR

Quiet
AS THE MOUNTAIN HEIGHTS

For Particulars, Call
CITY TICKET OFFICE
MAin 0575
116 Dixie Terminal Arcade
CINCINNATI

NORFOLK AND WESTERN RAILWAY

ADVERTISEMENT FOR THE POCAHONTAS AND CAVALIER. The *Cavalier* was named for the Hotel Cavalier, a resort in Virginia Beach, Virginia. The *Cavalier* began service on April 1, 1927. The *Cavalier* ran for 40 years, moving passengers from Virginia's coast to Ohio, before it was combined with the *Powhatan Arrow* in April 1967.

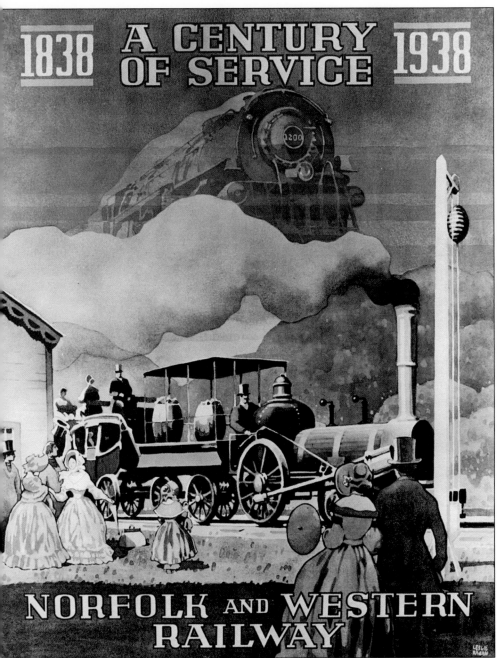

ANNIVERSARY POSTER. In 1938, the Norfolk and Western celebrated "A Century of Service" with this poster proudly displayed in its stations and depots, as well as in other print advertising. While the N&W was not formally birthed until 1882, it was the culmination of earlier railroads and thus the use of the year 1838 as its beginning point.

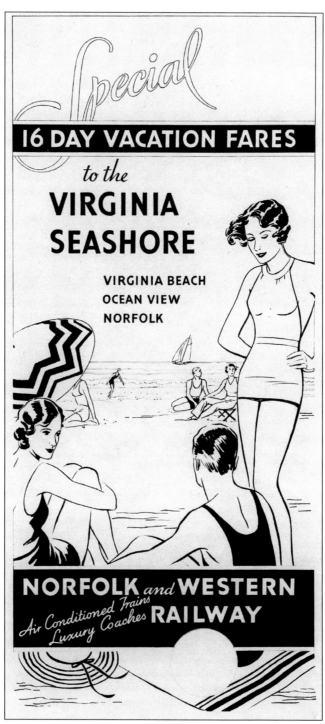

VACATION ADVERTISEMENT. While passenger service was never a large percentage of the N&W's business compared to coal, for example, it did take its passenger service seriously and offered many amenities. This May 1935 advertisement boasts of its service to the resorts and hotels of Virginia's shore.

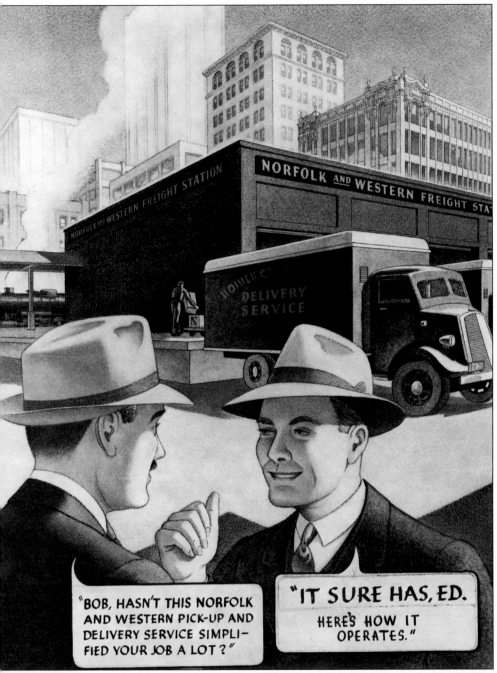

Freight Advertisement. The Norfolk and Western used its rails to haul a variety of freight, not just coal, and in so doing contributed significantly to the economic development and vitality of the communities it served. This "pick-up and delivery" advertisement is from 1944.

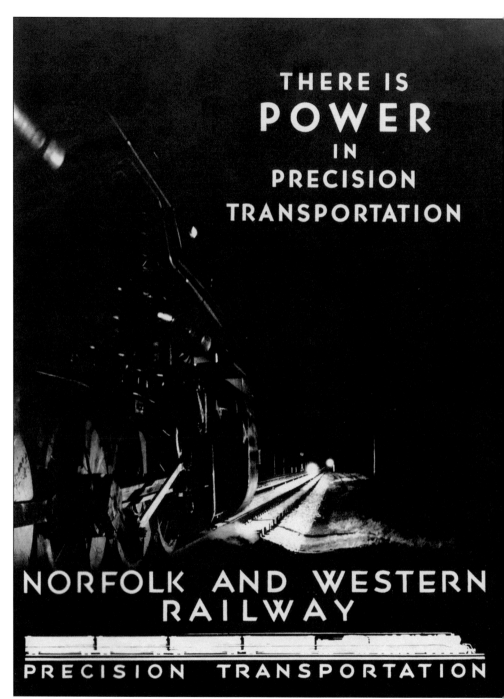

PRECISION TRANSPORTATION. The Norfolk and Western developed a variety of slogans to illustrate its dependability and efficiency. For many years, the "Precision Transportation" motto was used to underscore its image as a muscular, expansive rail carrier, as shown here in this advertisement from 1939.

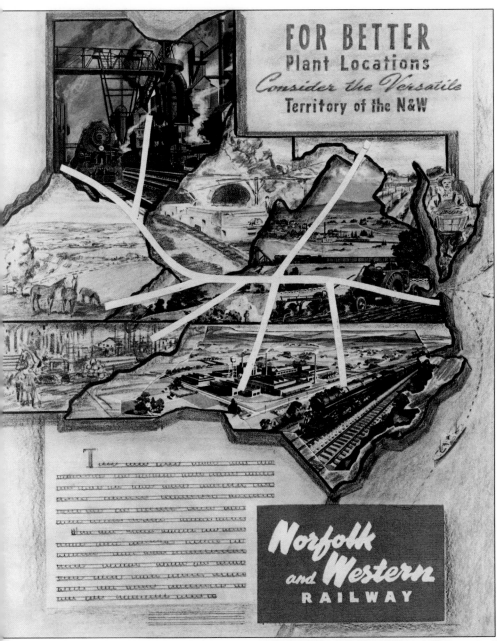

ECONOMIC DEVELOPMENT. Many may not have appreciated that the Norfolk and Western had an economic development office that worked with industries, businesses, and municipalities in locating sidings and attracting commercial enterprises to be in proximity to its rail service. The above advertisement is undated. The ability of the railroad to locate rail sidings and infrastructure was often critical to communities being able to attract and retain industry.

PASSENGER CAR. The Norfolk and Western used many stock images to promote its passenger service. This image, from October 1941, shows the interior of a Class PM passenger car. Passenger service posed economic challenges for the N&W as there were, in 1950, only nine communities being served by the railway between Norfolk and Cincinnati-Columbus that had populations of more than 15,000.

DRESSING ROOM. This image, also from October 1941, shows the ladies' dressing room on the Class PM passenger car. The Norfolk and Western's passenger service ended in 1971 with the coming of Amtrak. Passenger service had steadily diminished primarily because of the increased use of the automobile and an improved highway system for auto traffic.

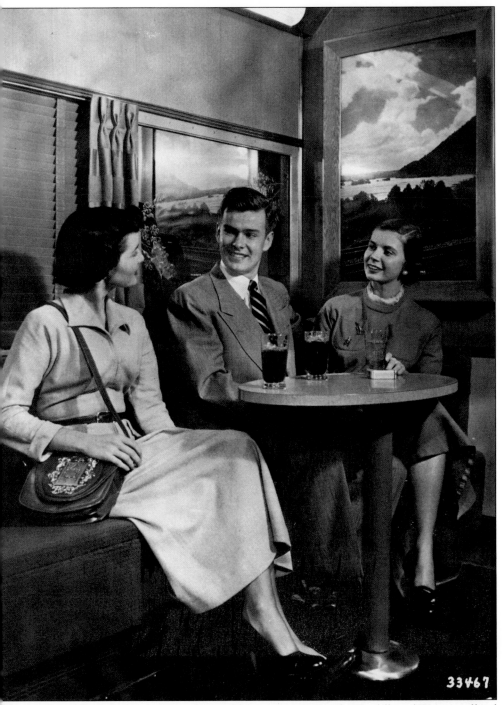

TAVERN CAR. The tavern car promoted one of the many amenities the Norfolk and Western offered their passengers. This shows a Tavern/Lounge Car, Class P4. Interestingly, Virginia was for many years a "dry state," which limited what beverages could be offered in the N&W's tavern car.

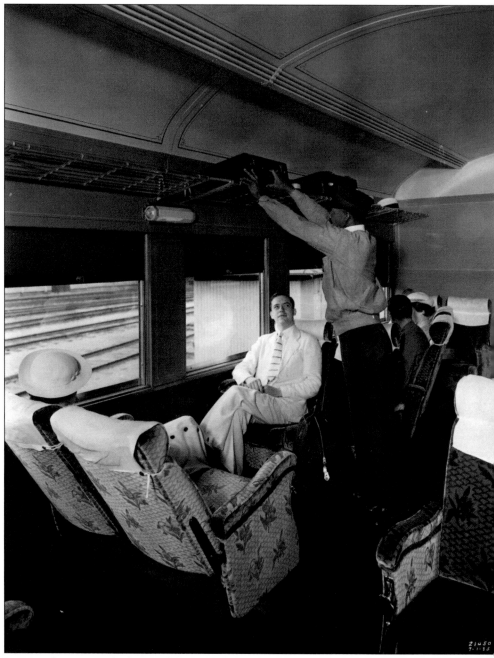

Luxury Coach. With the Norfolk and Western starting many of its famed passenger trains in the 1920s, the railroad wanted to make certain that potential customers understood the value and comfort of rail travel. This photograph from July 1935 shows the interior of a luxury coach.

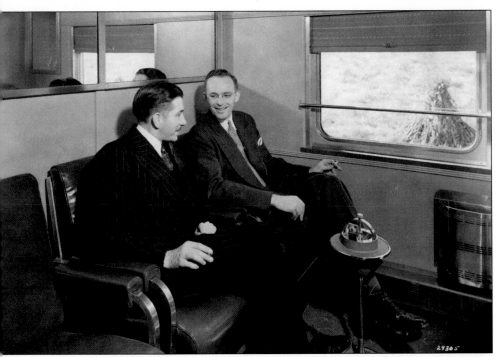

SMOKING ROOM. By today's standards, such a designation seems inappropriate, but the comfort of passengers was a serious concern. This "Smoking Room" was on a Class PM passenger car, and the image is dated 1941.

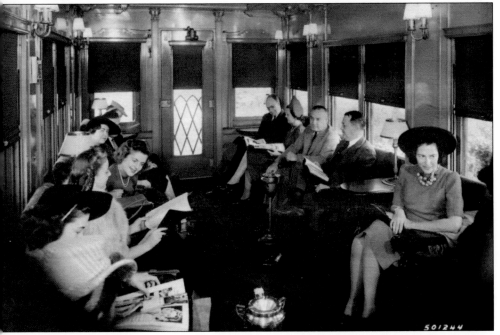

LOUNGE CAR. This 1942 photograph shows the interior of a lounge car. Some of the passenger trains offered spectacular scenic vistas, especially along the New River, which could be enjoyed by passengers. The tavern-lounge was discontinued on the *Pocahontas* in January 1963.

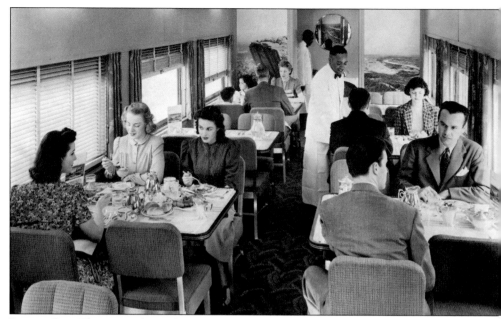

DINING CAR. This image shows the interior of a dining car in the 1940s. The Norfolk and Western had distinct chinaware for its dining service, which is now sought after by collectors. It also used distinct Dogwood-patterned chinaware in its Hotel Roanoke.

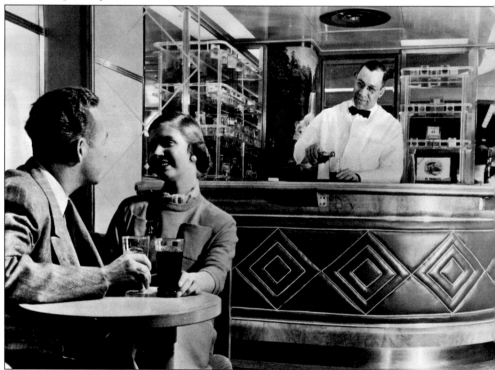

OBSERVATION CAR. This c. 1949 image shows the interior of a Lounge Tavern Observation Car Class P4. To showcase the new cars, the railroad used models, as is the case in this photograph many of whom were employees.

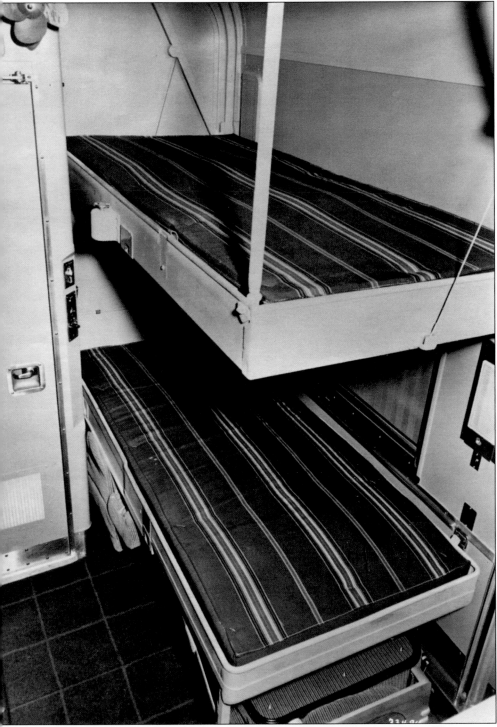

SLEEPING CAR. This photograph shows the longitudinal bedroom of a Class S1 Sleeping Car. By the mid-1960s, many of the sleepers had been cut back to just a few lines or were eliminated altogether.

LOUNGE CAR. This lounge car was on the *Tennessean*. The *Tennessean* began running on May 17 1941, between New York and Memphis, and was a joint operation of the N&W and the Southern Railway. The *Tennessean* was discontinued in 1966. The above image is from its first year, 1941

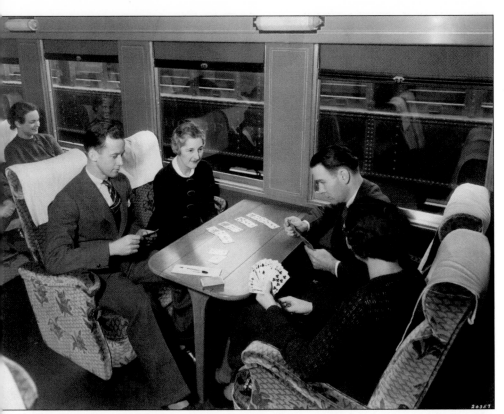

PASSENGER CAR. This 1934 photograph shows a Class PH, air-conditioned passenger car, No. 700. Modern passenger service in regard to the Norfolk and Western was considered by many to have commenced in 1946 with the launch of the *Powhatan Arrow*.

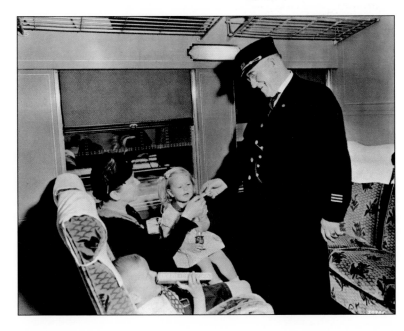

CONDUCTOR. This stock photograph shows a conductor taking a ticket from a woman and child in 1944. Note the uniform of the conductor. N&W uniforms were known for their brass buttons that contained the logo of the railroad. Today the uniforms and the buttons are valued by collectors.

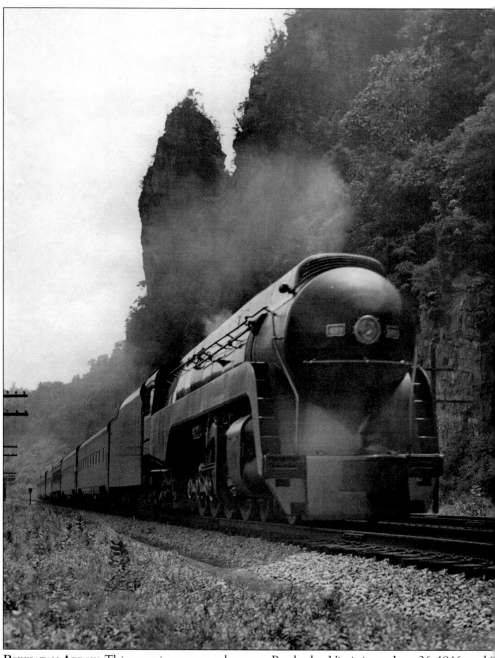

POWHATAN ARROW. This great image was taken near Pembroke, Virginia, on June 26, 1946, and it shows the J-Class Engine No. 609 pulling the *Powhatan Arrow*. The *Arrow* was perhaps the most well known of the N&W's passenger trains, and the J-Class was a storied steam locomotive developed by the railway. Together, these two elements showcased the best of the N&W Railway.

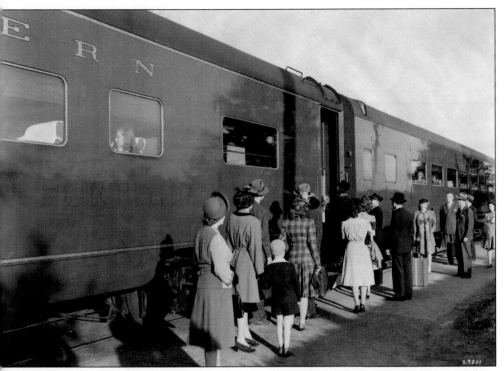

PASSENGER CARS. This image was taken on October 31, 1941, and shows Class PM cars at Salem, Virginia. As a side note, the Norfolk and Western was the last major railroad to abandon steam and switch to diesel power. This change was announced in 1958 by then-president Stuart Saunders, who sought to modernize the railway's operations.

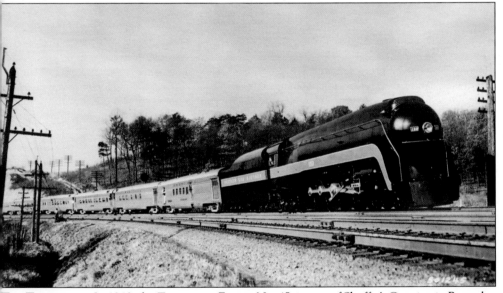

THE TENNESSEAN. In 1940, the *Tennessean*, Engine No. 45, is west of Shaffer's Crossing in Roanoke, Virginia. In 1966, its last year, the *Tennessean* was combined with another train, the *Pelican*, and was known as the *Pelican-Tennessean*. In August 1970, the *Pelican* was combined with the *Birmingham Special.*

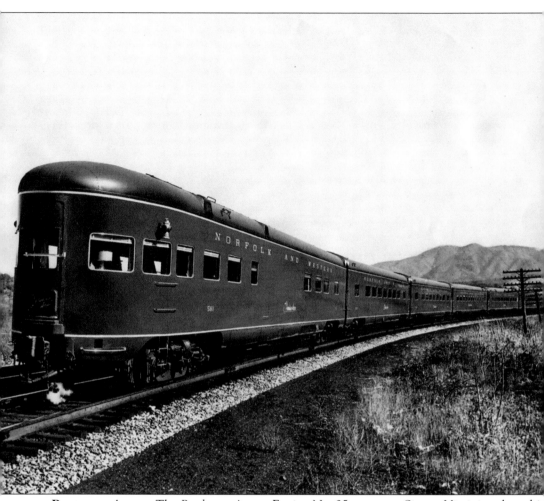

POWHATAN ARROW. The *Powhatan Arrow*, Engine No. 25, was near Singer, Virginia, when this 1940s image was taken. The *Powhatan Arrow* made its maiden west-bound run on April 28, 1946 from Norfolk to Cincinnati, a journey of nearly 678 miles. As with the *Pocahontas*, a contest was held to name the train, and the winning selection came from a retired section foreman, Leonard A. Scott.

FURTHER INFORMATION AND RESEARCH

National Railway Historical Society
100 North Twentieth Street, Suite 400
Philadelphia, PA 19103-1462
www.nrhs.org

Norfolk and Western Historical Society
P.O. Box 13908
Roanoke, VA 24038
www.nwhs.org

Norfolk Southern Railway Historical Society
2222 West Club Boulevard
Durham, NC 27705
www.norfolksouthernhs.org

Railroad Station Historical Society
26 Thackeray Road
Oakland, NJ 07436-3312
www.nrhs.org

Virginia Museum of Transportation
303 Norfolk Avenue
Roanoke, VA 24016
www.vmt.org

Discover Thousands of Local History Books
Featuring Millions of Vintage Images

Arcadia Publishing, the leading local history publisher in the United States, is committed to making history accessible and meaningful through publishing books that celebrate and preserve the heritage of America's people and places.

Find more books like this at
www.arcadiapublishing.com

Search for your hometown history, your old stomping grounds, and even your favorite sports team.